Sylvie Germain

Germa

Magnus

Translated and with an
Afterword by Christine Donougher

Dedalus

Dedalus has received support for this book from the French Ministry of Foreign Affairs, as part of the Burgess programme run by the Cultural Department of the French Embassy in London, the French Ministry of Culture in Paris and the Grants for the Arts programme of the Arts Council England in Cambridge.

Liberté • Égalité • Fraternité
RÉPUBLIQUE FRANÇAISE

LOTTERY FUNDED

Published in the UK by Dedalus Ltd
24–26, St Judith's Lane, Sawtry, Cambs, PE28 5XE
email: info@dedalusbooks.com
www.dedalusbooks.com

ISBN 978 1 903517 62 8

Dedalus is distributed in the USA by SCB Distributors,
15608 South New Century Drive, Gardena, CA 90248
email: info@scbdistributors.com web site: www.scbdistributors.com

Dedalus is distributed in Australia by Peribo Pty Ltd
58, Beaumont Road, Mount Kuring-gai N.S.W. 2080
email: info@peribo.com.au

Dedalus is distributed in Canada by Disticor Direct-Book Division
695, Westney Road South, Suite 14, Ajax, Ontario, LI6 6M9
email: ndalton@disticor.com web site: www.disticordirect.com

First published in France 2005
First published by Dedalus in 2008

Printed in Finland by WS Bookwell
Typeset by RefineCatch Limited, Bungay, Suffolk

A C.I.P. listing for this book is available on request.

THE AUTHOR

Sylvie Germain was born in Chateauroux in Central France in 1954. She read philosophy at the Sorbonne, being awarded a doctorate. From 1987 until the summer of 1993 she taught philosophy at the French School in Prague. She now lives in Pau in the Pyrenees.

Sylvie Germain is the author of eleven works of fiction, ten of which have been published by Dedalus. Her works of non-fiction include a study of the painter Vermeer, a life of the 20th-century Dutch mystic Elly Hillesum, a portrait of Warsaw, and a religious meditation. Her work has been translated into over twenty languages and has received worldwide acclaim.

Sylvie Germain's first novel *The Book of Nights*, was published to France in 1985. It has won five literary prizes as well as the TLS Scott Moncrieff Translation Prize in England. The novel's story is continued in *Night of Amber*, which came out in 1987. Her third novel *Days of Anger* won the Prix Femina in 1989. It was followed by *The Medusa Child* in 1991 and *The Weeping Woman on the Streets of Prague* in 1992, the beginning of her Prague trilogy, continued with *Infinite Possibilities* in 1993 and then *Invitation to a Journey* (*Eclats de sel*). *The Book of Tobias* saw a return to rural France and la France profonde, followed in 2002 by *The Song of False Lovers* (*Chanson des Mal-Aimants*).

Magnus, published in 2005, has won several prizes in France including the Goncourt Lycéen Prize, which is selected from the 12 novels on the Goncourt shortlist by 15–18 year old students at French High Schools. It was also shortlisted for the Grand Prix du Roman de L'Académie Française.

THE TRANSLATOR

Christine Donougher read English and French at Cambridge and after a career in publishing is now a freelance translator and editor.

Her translation of *The Book of Nights* won the 1992 Scott Moncrieff Translation Prize.

Her translations from French for Dedalus are: 7 novels by Sylvie Germain, *The Book of Nights*, *Night of Amber*, *Days of Anger*, *The Book of Tobias*, *Invitation to a Journey*, *The Song of False Lovers* and *Magnus*, *Enigma* by Rezvani, *The Experience of the Night* by Marcel Béalu, *Le Calvaire* by Octave Mirbeau, *Tales from the Saragossa Manuscript* by Jan Potocki, *The Land of Darkness by Daniel Arsand and Paris Noir* by Jacques Yonnet. Her translations from Italian for Dedalus are *Senso (and other stories)*, *Sparrow and Temptation (and other stories)*.

To Marianne
and Jean-Pierre Silvéréano

What has not been said at the proper time is perceived at other times as pure fiction.

Aharon Appelfeld

Prelude

A meteorite explosion may yield a few small secrets about the origins of the universe. From a fragment of bone we can deduce the structure and appearance of a prehistoric animal; from a vegetal fossil, the presence long ago in a now desert region of a luxuriant flora. Infinitesimal and enduring, a plethora of traces survive time out of mind.

A scrap of papyrus or a shard of pottery can take us back to a civilization that disappeared thousands of years ago. The root of a word can illuminate for us a constellation of derivations and meanings. Remains, pit-stones always retain an indestructible kernel of vitality.

In every instance, imagination and intuition are needed to help interpret the enigmas.

Take a man whose memory is defective, long steeped in lies then distorted by time, plagued with uncertainties, and one day all of sudden made incandescent, and what kind of story can you write about him?

A sketch portrait, a confused narrative, punctuated with blanks, gaps, underscored with echoes, and ultimately fraying at the edges.

Never mind the confusion. The chronology of a human life is never as linear as is generally believed. As for the blanks, gaps, echoes and frayed edges, these are an integral part of all writing, as they are of all memory. The words of a book are no more monolithic than the days of a human life, however abounding these words and days might be, they just map out an archipelago of phrases, suggestions, unexhausted possibilities against a vast background of silence. And this silence is

neither pure nor tranquil; there is an underlying murmur, a continuous whispering. A sound rising from the confines of the past to mingle with the sound gathering from all reaches of the present. A breeze of voices, a polyphony of whisperings.

Inside every person the voice of a prompter murmurs in an undertone. Incognito. An apocryphal voice that if you only lend an ear may bring unsuspected news – of the world, of others, of yourself.

To write is to descend into the prompter's box and learn to listen to the breathing of language in its silences, between words, around words, sometimes at the heart of words.

Fragment 2

On every object, every person, including his parents, he poses a gaze full of candour and amazement, studying everything with close attention. The gaze of a convalescent who has come close to death and is relearning to see, to speak, to name things and people. To live. At five years of age he fell seriously ill and the fever consumed all the words inside him, all his recently acquired knowledge. He is left with not a single recollection. His memory is as blank as the day he was born. However, it is sometimes traversed by shadows that come from he knows not where.

His mother, Thea Dunkeltal, devotes her entire time to reeducating her amnesiac and unspeaking child. She teaches him his language once again and gradually restores to him his lost past, recounting it episode by episode, like a story told in instalments of which he is the central character and she the good queen looking after him. She delivers him into the world for the second time by the sole magic of the spoken word.

In this fairy-tale by instalments, like all fairy-tales a spellbinding blend of the fearsome and the marvellous, every member of his family has the stature of a hero: he as the victim of a galloping fever that he has nevertheless managed to overcome; his mother in the role of the good fairy; his father that of a great doctor. In addition to this trio are two other characters, even braver and more admirable, who are his mother's younger brothers, killed in the war. It is his duty to acknowledge them with pride and gratitude for evermore. Because it was for him they sacrificed themselves by going off to fight in a distant land where the men are as cruel as the climate, so that

11

he might grow up in a country of power and glory. And the child, who confuses the words 'enemy' and 'illness', imagines that his warrior uncles died battling against his illness, died of cold and exhaustion driving back the fever-foe into an icy waste so as to extinguish its burning heat. Bearing their first names, he meekly allows himself to be transformed into the living mausoleum of these two heroes.

Seductive as this family epic full of nobility and sadness might be, it nevertheless suffers from one defect that, although apparently small, greatly upsets the child: his mother grants no place in it to Magnus, whom she treats in fact with scorn, even revulsion. However, Magnus and he, Franz–Georg, are inseparable. So he secretly introduces his companion into the legend, inventing scenes for him murmured at length into his ear (the one that bears traces of burning, to soothe it) when they are alone together. Scenes in which Magnus has a role equal to his own.

Note

Magnus is a medium-sized teddy bear with a rather worn coat of light-brown fur turned slightly orange in places. A faint smell of scorching emanates from him.

His ears are made of two large circles cut out of a piece of soft leather. They have the reddish-brown colour and smooth shiny appearance of chestnuts. One is intact, the other half burned away. An oval cut out of the same piece of leather trims the end of each of his paws. His nose consists of strands of black wool closely stitched in the shape of a ball.

His eyes are unusual, with the same shape and of the same gleaming gold as the buttercup flower, giving him an expression of gentleness and amazement.

He wears a square of cotton rolled up round his neck, embroidered with his name in large multi-coloured letters. Crimson M, pink A, violet G, orange N, midnight-blue U, saffron-yellow S. But these letters have lost their brilliance, the threads are grubby and the cotton has yellowed.

Fragment 3

He spends most of his time observing his surroundings. They say he is too dreamy, inactive. But no, it is very serious work he is doing, studying at length the landscape, the sky, objects, animals and people, striving to engrave it all on his memory. A memory that has been as amorphous and unstable as sand. He is now endeavouring to give it a mineral-like solidity.

He likes the land that extends round his village, the pink mist of gorse, the ponds and juniper copses, and above all the forests of silky-white birch trees, gleaming in the twilight when the blue of the sky darkens. The contrasts of colours and of luminosity fascinate him. In skies heavy with dark clouds he seeks for the breaches of sunlight, the glimpses of periwinkle blue, and on the greenish water of the marshes, for patches of brilliance, on mossy rocks, the fleeting glint of the stone's texture, like a flash of silver ore. But he is afraid of the dark, which swallows up shapes and colours, and casts him into a state of anguish. It is then that he hugs Magnus to his breast, like some ridiculous cloth shield, and whispers fragments of incoherent stories into his ear, preferably the left ear, the one that has been injured and therefore needs special care. Just as his mother cajoles him by lulling him with stories, he comforts Magnus by caressing him with words. In words there are so much power and gentleness combined.

Adults disconcert him. He does not understand their anxieties or their pleasures, and still less the bizarre things they sometimes say. There are times when they bray with joy or anger. When he hears this too loud, crude laughter, or these angry cries, he retreats into himself. He is overly sensitive to voices,

to their texture, pitch, volume. His own voice sometimes sounds strange, as if his throat were left raw by the wheezing and tears that racked him when too severely afflicted by the fever during his illness.

He loves his parents with all his heart but he observes them too with perplexity from his deep loneliness as an only child, especially his father, who intimidates him and of whom he never dares ask any question.

Clemens Dunkeltal is a doctor but he has no private patients, nor does he work in a hospital. The place where he practises his profession is not far from their village though Franz-Georg has never been there. Judging by his majestic demeanour, his air of gravity, Dr Dunkeltal must be an important man – a health wizard. He receives patients by the thousand in his vast country asylum, and all undoubtedly suffer from contagious diseases since they are not allowed out. Franz-Georg wonders where these hordes of sick people can possibly come from. From all over Europe, his mother told him one day with a faint pout of mingled pride and disgust. The child looked in an atlas and was left speechless: Europe is so vast, its peoples so numerous.

His father is often away, and when at home pays but little attention to his son. He never plays with him or tells him stories, and when he does deign to show any interest in him, it is only in order to criticize him for his passivity. Franz-Georg can find neither the boldness nor the words to explain that observation is not at all laziness but a patient exercise in training his memory. He swallows back tears of impotence at not being able to express what he thinks and feels, and most of all tears of sadness at failing to please his father.

But there are those magical evening when Clemens turns into a bountiful king, when accompanied at the piano by his wife or one of the friends they have invited to dinner, he takes up a

position in the middle of the drawing room, standing very erect in the pale somewhat acid light cast by the chandelier, and in his bass baritone voice gifted with amazing plasticity he sings songs by Bach, Schütz, Buxtehude or Schubert. His mouth opens wide, like a dark abyss where a storm-beset sun trembles and rumbles. The light plays on the metal frame of his spectacles and his eyes disappear, as though they had become one with the glass discs. Then his clean-shaven face, with receding hairline and aquiline nose, looks as if it too is cast in some white metal, or kneaded out of dough. A stark shiny mask, as worn by the chorus in Greek drama. And he sketches in the air the slow movements of a seed thrower. He has beefy hands but his fingernails are perfectly manicured, and they gleam under the ceiling light.

The child listens, holding his breath to allow more room for his father's, in all its powerfulness and agility. The voice of a master of darkness whose menacing forces he overcomes just as he managed to defeat the fever-foe. For Franz-Georg is convinced it is by singing in this way that his father must have helped him to get better, and surely this is how he treats the countless patients who have come flocking to him from all over Europe. And the child enfolds himself in this vocal chrysalis, denser and more voluptuous than the drawing room curtain of purple velvet in which he sometimes likes to hide.

It is for this voice, the voice of enchanted evenings, that Franz-Georg loves his father and has boundless admiration for him. Never mind if his father shows little affection, even though this is hurtful. His singing is enough to console him for this distress, or at least transform it into contented melancholy. His father is distant but his singing is a haven, a pleasure. He harbours a nocturnal sun within his breast.

Sequence

Night Song in the Forest

Hail to you always, O Night!
But twice hail to you here in the forest,
where your eye has a more secret smile
where your footstep falls yet more softly!

Yours is a language of whispering breezes,
Your paths, interwoven shafts of light,
Whatever your mouth but quiets with a kiss
Grows heavy-eyed and sinks into a slumber!

And as we cry out in song:
'Night is at home in the forest!'
So the lingering echo replies:
'She is at home in the forest!'

So twice hail to you here in the forest,
O gracious Night,
Where all the beauty of your array
Appears yet more beautiful.

Nachtgesang im Walde
a choral work by Franz Schubert
based on a poem by Johann Gabriel Seidl

Fragment 4

The father has seemed preoccupied for some time, holding long discussions with the mother, or with some of their friends who seem just as vexed. The child is kept isolated from these conversations, of which he nevertheless catches fragments. Among the words that often recur in these discussions there is one that intrigues and disturbs him: typhus. The patients in Dr Dunkeltal's care are succumbing to this infection in their thousands. Franz-Georg has tried to find out more but it is harder to find out the meaning of a word in a dictionary than the whereabouts and size of a continent in an atlas, for he cannot yet read very well. But since he hears the words 'war, enemy, defeat' spoken more often, he again identifies them with the word 'illness', and therefore 'typhus'.

There is no such confusion in Clemens Dunkeltal, and it is with bitter lucidity that he realizes the extent of the growing danger. Day by day he and his friends lose their arrogance, becoming increasingly tense and irritable, and looking harassed and aggressive. Even his jovial companion Julius Schlack, who brightened so many evenings at their house, and Clemens' colleague Horst Witzel, a poet in his spare time, who seizes every opportunity to recite long works by Kleist, Goethe, Herder, Hölderin and Schiller, no longer joke or declaim. Suddenly they all change their way of dressing, of greeting each other, of behaving. They abandon their very impressive uniforms, their noisy and solemn salutes, they lower their tone and adopt a less martial attitude. They end up hugging the walls. And so closely do they hug them, they almost seem to walk through them and turn themselves into currents of air.

One night in March the Dunkeltals flee from their home

with the stealth of thieves. Holding on to his mother with one hand, Franz-Georg clutches his bear in the other to dispel his fear of the dark and of the unknown. In his mind they are fleeing a dreadful enemy called typhus, which has come from every corner of Europe. Is it the same fever as the one that almost killed him two years ago? If so, his uncles must have died in vain, and the family legend be no more than a delusion.

They head southwards. But the south seems to keep receding, so long is their journey, continually zigzagging in constant panic. They wander through desolate countryside, through towns and villages in ruins, passing hordes of distraught people. Sometimes they take refuge for several days in a cellar or barn. They are hungry but fear assails them even more.

They have lost everything, even their names. They have swopped that of Dunkeltal for Keller: the parents are now called Otto and Augusta Keller, and he simply Franz Keller. Only his bear Magnus is entitled to retain his original identity. The child interprets this absurd alteration in his own way. He tells himself that in the bewildering confusion that now prevails, where the least thing, even a crust of bread, a cigarette butt, becomes a tradeable item, a name too can have an exchangeable value. But exchangeable for what, to what advantage – this he does not understand, and his parents do not really explain, merely forbidding him to make any reference to his real name, the house they have left, the region where they used to live, even his father's profession. The child listens to these instructions whispered to him in a tone of peremptory secrecy, and obeys without argument. He is meek and reserved by nature, accustomed to living on the margins of adult society, with so much of what they say and do remaining a mystery to him. He keeps to himself his bewilderment, his doubts and questions, and lets them gravely mature in his solitude. But the sight of towns laid waste, of terrified crowds

fleeing along roads where unbelievable scenes erupt from time to time as panic reaches fever-pitch, and the roar of planes cutting through the sky cast him into a state of stupefaction and nausea that soon translates into dull pains in his belly, as if all these images of collapse were rotten fruit, bits of contaminated meat ingested through his eyes, ravaging his entrails. At night these distorted images stir in his insides with the heavings of muddy waters and he wakes up crying, curled up round Magnus.

And then his father parts company with them, leaving him and his mother to continue this journey through hell by themselves. He says he will rejoin them as soon as he can but for safety's sake he still has to hide, and without him they will travel faster. This is true. As soon as his father goes his own way, the endless journey improves, as if they had been relieved of a burden hampering their southward progress. All the same this separation is painful for the child.

Augusta Keller and her son Franz come to a small town that even a few weeks ago must have been very pretty. Now it is no more than ruins on the edge of a lake. Here, their wandering finally comes to an end and their wait for his father's arrival begins.

Note

Friedrichshafen: a town in south-west Germany, situated on the northern shores of Lake Constance.

In the 19th century the town served as a summer residence for the Württemberg royal family.

The town's history is marked by Ferdinand von Zepplin, who at the end of the 19th century set up production here of airships or dirigible balloons of rigid type.

Important industrial centre in the early 20th century (construction of aeroplane engines).

At the end of the Second World War the town was the target of heavy aerial bombing by the Allies; the old town was almost totally destroyed.

Fragment 5

Augusta Keller proves to be a dour double of friendly Thea Dunkeltal. She has lost her lovely house, her social status and her circle of acquaintances, every one of whom deferred with great compassion and respect to her deep mourning for her two young brothers, sacrificed so that the Reich might be vastly extended in time and space. Above all she has lost the dream of grandeur that helped her to bear with courage a sister's grief for the loss of her younger siblings, heroes whose frozen bodies, lying unburied somewhere in the East, in a land of snow and barbarism, must have been devoured by stray dogs or wolves.

The Führer is dead, the clarion-voiced incarnation of this dream of splendour himself, and with him, after a derisory dozen years, the thousand-year Reich has foundered. Nothing is left of her two combined passions, patriotic and fraternal, nothing but ruins, ashes and bones. She has just seen her nation pass overnight from triumph to catastrophe, the country's beautiful towns collapse like smoking ant-hills, and her people, once so proud, reduced to bands of fugitives steeped in fear, poverty and shame. She feels outrageously cheated, robbed, and as the days go by her plight is poisoned with bitterness. But she is strong, determined to fight for survival, and she girds herself with patience to await the return of her husband. Thanks to relatives of his in Friedrichshafen, she finds a room where she can stay with her son, in a part of town away from the centre spared by the bombings, and a job as a cook in a hospital. The salary is derisory but the position ideal for scrounging enough to avoid dying of hunger.

Despite her tiredness she still finds time in the evenings to tell her son stories. She knows that everything he has

seen in the course of their journey through scenes of devastation has traumatized him. Every night he wakes with a start, cries out, wails. Then she takes him in her arms, cradles him to her body, and recounts in a quiet voice the much-repeated yet sadly belied family saga. She embroiders, illumines the past, blotting out as much as she can the memories of recent weeks and promising a radiant future. As soon as his father returns, everything will get better. Life will resume as before, elsewhere and different of course, but as before, yes, even better than before. She thrills as much as the child to the tales she weaves in the darkness of their wretched room.

And the days go by, at once dreary and fraught, oppressive days of waiting, of feeling bereft and anxious. But sustained with hope. One autumn evening his father finally reappears – or rather the shadow of his father. Otto Keller is not even an enfeebled double of powerful Clemens Dunkeltal but a pathetic imitation. He has shrunk into a grimy fugitive, grown very thin, ill-shaven, the look in his eyes that of a hunted animal, a vicious beast. Franz observes with dismay his king of darkness overthrown, drained of his power, shorn of all magic. Can he even sing any more with his poor lanky stooped body? What has become of the night sun that resounded voluptuously in his chest? Has he swopped that too, like his name, his watch and so many other things, for food or false papers? But the joy of seeing him again, still alive, outweighs the mortification of finding him so reduced. The child stays with him as much as he can, expressing with his eyes what his lips dare not articulate: not to worry about any of this, that most of all he still loves him, perhaps even more than before. Yes, more, because pity for his father now outweighs the fear Dunkeltal used to inspire in his son in his days of glory. And at least now his father does not go away any more as he did when he had important responsibilities. He remains most of

23

the time locked in their room, only rarely venturing out and always after nightfall.

Such are the thoughts of the child who, beguiled by the masterfully constructed conceit of his mother, still has no understanding of events and innocently lives his life cut off from reality, despite all the brutality this reality brings to bear and he has to suffer. But hunger and destitution seem almost easy to endure with his parents reunited. And then there is a great project in the making: the plan is to go to a distant country across the seas. The name of this country, which he often hears mentioned by his parents in the evenings, has the brightness of a promise, the beauty of a dream, the magic spell of a secret: Mexico.

Mexico – this for all three of them is their secret, their hope, their future.

One night his father returns very happy from one of his discreet outings. He has procured the money and papers necessary for his journey. He is at last equipped to set off for Mexico ahead of his wife and son who will rejoin him as soon as he can bring them over without danger. He proudly shows Augusta-Thea his new papers in the name of Helmut Schwalbenkopf, and this avian surname amuses him. 'Schwalbenkopf, swallow's head, now that's a good omen for undertaking this perilous migration!' Then he adds with a peculiar smile, 'Ah, good old Helmut . . .' and he goes on to recite in a playful tone a verse from a poem by Eichendorff:

'If you have a friend in this world, don't trust him at this hour, though with friendly eyes and smiling mouth, he is planning war in perfidious peace.'

Franz listens to him, a little bewildered, and taking his hand asks, 'Please sing, father . . .' As his newly effected transmutation into Helmut Schwalbenkopf has put him in a good mood, his father sings mezza voce a Schubert lied that deliciously thrills the child.

Note

Schwalbenkopf, Helmut: born 1905 at Friedrichshafen, Bade-Wurtemberg. Baker.

Married in 1931 to Gertrud Meckel, born 1911.

Two children: Anna-Luisa, born 1934, and Wolf, born 1937.

Enlisted in 1939, sent to Poland, where he is wounded, and later to Russia, where he is taken prisoner. Freed in 1946, he returns home.

Back in Friedrichshafen, he discovers his wife and two children have died and his bakery was destroyed in the bombardment of the city at the end of the war.

Reduced to vagrancy in his own city, one evening in March 1947 he disappears. No one knows what has become of him. Some people assume he committed suicide, but his body has never been found. Maybe he threw himself into the lake, whose waters are the most secret and inviolable of graves.

Fragment 6

His father has gone away again, on a very long journey this time. And the waiting resumes, even more tense than last time. Thea, who retains her pseudonym of Augusta Keller, once again girds herself with patience but under the stress of tiredness and anxiety, increasing as the days go by, she becomes harsh and irritable. She stops coddling her son and begins more and more often to scold him. Suddenly she thinks he is too dreamy, lazy, that he has outgrown childhood and it is high time he put it behind him. She takes over the father's fault-finding and severity towards the boy.

It is true that Franz is already nine years old but he is in no hurry to join the ranks of adults. As he gets older he begins to have a better understanding of their behaviour, their pleasures and worries, but without any insight yet into their implications. Nor does he attempt to deepen his understanding of the obscurity of grown-ups, for the little he is able to puzzle out does not seem very appealing. He has a sense of something small-minded, wretched even on occasion, about their preoccupations as well as their satisfactions. And besides they are not very reliable. For years they go quietly about their business, then suddenly drop everything, abscond, change their name as readily as they would their shirt, and ultimately flee to the ends of the earth.

That is not the worst of it: adults are capable of destroying everything, burning everything – houses, bridges, churches, roads, entire cities. He has seen this and he still lives in a landscape of ruins. But apparently there is even worse madness than this: the destruction not only of cities but of entire peoples. This is beyond young Franz's comprehension. He has

heard some incredible stories and above all seen photographs at once mesmerizing and blinding to look at: piles of skeletal bodies like bundles of pine wood thrown in a heap, living-dead with enormous haunted eyes sunk in black holes, children so thin and ragged they look like little old men, their bald heads too heavy for necks reduced to the size of a rhubarb stalk. And far from offering any explanation and helping him to confront these revelations that provoke mental combustion and leave his mind prostrate, in shatters, his mother refuses to discuss them. She even persists in denying the evidence, going so far as to denounce the news as lies and the published photographs as fakes. And she declares with as much conviction as rancour that it is precisely because of all these slanderous untruths spread by the victors that her husband was compelled to flee. And she says she cannot wait to go and join him, to leave for ever this country she once so loved but that has lost all greatness since being orphaned of its Führer. Franz does not know how or what to think. It is hard for him to identify the boundaries of reality, to distinguish truth from mystification. He detects a strong whiff of bad faith and dishonesty in his mother's acrimonious words but he is still under Thea's influence and what she says carries weight, for better or worse.

Similarly, he asks himself questions about his father, whose name, like those of his friends Julius Schlack and Horst Witzel, has been extensively cited in the course of trials being held since the end of the war, but so monstrous are these questions they are checked by a wall of amazement. His father is declared a 'war criminal'. The enormity of the term makes it inconceivable; Franz is unable to grasp exactly what it means. He is all the more unable to do so because in his heart of hearts he does not really want to understand, so frightened is he of having to deal with a truth he suspects is ghastly. Is Dr Dunkeltal's crime his failure to overcome the typhus that killed thousands of the patients in the camp where he

worked? This seems unfair to the child, incapable of daring to imagine any offence other than incompetence. In the face of everything, he retains a prestigious image of his father and wants to see him again, to hear once more the deep soothing sound of his singing. No, Franz certainly has no desire to emerge from the state of ignorance natural to childhood, is in no hurry to throw himself into the cruel fray of the adult world. Besides, he has not had his full share of childhood. Illness robbed him of a very great part of it, war and the exodus spoilt the rest. And this lost part distresses him, causes him pain, like an amputated limb that continues to send twinges through the amputee's body. So rather than upset himself by probing the accusations against his father, he prefers to look towards the eclipse of his own past and peer into the strange black hole that swallowed up his early childhood.

By concentrating on this mystery lying dormant in the depths of his being, he reinforces it. Sometimes he can feel it quivering in his flesh, then diffusing fleeting sensations under his skin such that he could not say whether they were painful or pleasurable. This always happens unexpectedly, but he soon notices that these inner frissons – like needles of fire inside his body, discharging in volleys and racing through his nerves, veins, backbone – occur on particular occasions: whenever there is a blaze of intense brash colour, such as the bright red and yellow of a fire suddenly gathering strength with a roar in the stove, a blinding midday sun, a pyrotechnic sunset of vivid orange and reds, the gigantic fissure of a saffron streak of lightning against the dark blue of the sky. Once, before such an explosion of incandescent brilliance, he felt a crescendo of excitement culminating in a seismic tremor in the most intimate depths of his body, a kind of upheaval no less violent than voluptuous from which he emerged exhausted and jubilant, dazed. He had just experienced his first orgasm without understanding what it was.

That is when he develops an obsession with colours and dreams of becoming a painter, though he has nothing but a few pathetic chalks and crayons with which he scribbles on bits of cardboard, for want of better materials. The results are so disappointing he soon abandons these attempts at drawing and contents himself with waiting for the eruption, here or there, of those splashes of virulent colour that throw him into a state of turmoil he dreads as much as he longs for.

Note

Dunkeltal, Clemens (born 13/04/1904): Obersturmführer in the SS.

Doctor of medicine. Served as camp doctor successively at KL Dachau, Sachsenhausen, Gross-Rosen, and Bergen-Belsen.

He made the selections of the deportees, sending the sick and the weakest to the gas chambers; personally took direct part in the extermination of numerous prisoners by administering phenol through an injection to the heart.

Sentenced in absentia to life imprisonment, he is being sought in Central America, where he is suspected of having managed to escape thanks to the support of the clandestine Nazi organization ODESSA.

Fragment 7

The days drag by, slowly, tediously. Augusta Keller counts them off in silence, counts them and recounts them, the way savers keep calculating the amount they have saved towards a better life. The more time passes, the greater her impatience to put her present meagre existence behind her. She awaits the signal that will allow her to rejoin her husband.

What finally comes is not a signal for departure but rather notification of a permanent standstill: she receives news that her husband is dead. After being on the run for nearly three years, moving on from one country to another and ending up in Mexico, he tried to settle down in the state of Veracruz. But there too he felt pursued, watched and in danger, and so, his strength and hope exhausted, he apparently committed suicide. The last name he adopted, the one he was hiding behind at the time of his death, was Felipe Gomez Herrara.

Augusta Keller has nothing to look forward to any more. Now in smithereens, her dream of getting away has come to nothing. The widow resumes her own name, that of Thea Dunkeltal. Since the worst has happened she has nothing more to fear, so nothing more to hide. Nor does she have anywhere to go, her parents died in the bombing of Berlin, and what family she has left, in Zwickau, is imprisoned on the other side of the border that now cuts through Germany like a suppurating scar. In the wilderness where she is now captive, Widow Dunkeltal starts turning round and round in circles. Ever tighter circles that soon become suffocating. She suffers from asthma but neglects to take care of herself. She just keeps plodding on towards her own extinction.

More lonely and bewildered than ever, Franz-Georg closes in

on himself. This is a closing-in on a breeze, for he lives with an acute sense of irrationality and insecurity. As during his convalescence in the Lüneburg countryside, near Celle, he seeks comfort in nature, earth and sky. He relishes being in the open, gratifying his senses, musing at length on everything. His musings consist of a kind of slow and reverent mastication of the visible, of sounds and smells. He loves the lake just as much as he loved the heath. That expanse of unruffled blue, constantly varying, going from milky azure to almost black violet or from opalescent lime to dark green, depending on the time of day. He never tires of studying the life of colours, their perpetual transformations, their quiverings, their slow effusions followed by abrupt changes.

And he always watches out feverishly for an explosion of ardent red, acid yellow, garish orange.

He ruminates on the world and more than ever on the accusations levelled against his father, as well as the circumstances of his death, which have remained obscure. But a mist always overlays his thinking, impedes his questioning, affection and abhorrence towards this man and now it is constantly warring inside him.

He summons up all the memories of his father he has hoarded. And having trained his memory since recovering from his illness to register the smallest details and keep them fresh in his mind, he manages to visualize the departed's figure, face, gait and gestures. This exercise in visualization demands a great deal of concentration and is carried out with his eyes shut. Behind the boy's eyelids, his father appears the way he was before his downfall. Franz-Georg avoids calling to mind the hunted outcast he subsequently became. That memory, his son relegates to the shadows. It is too painful, it heralds too cruelly the process of decline from fugitive to phantom. Indeed, his father is no more than a wandering phantom across the ocean.

He not only tries to resuscitate the deceased visually,

he strives even harder to bring back to life his voice. That massive voice with the capacity to envelop him in a mantle of breeze-filled darkness more ample and more tender than the night. '*Yours is a language of whispering breezes, / Your path interwoven shafts of light, / Whatever your mouth but quiets with a kiss / Grows heavy-eyed and sinks into a slumber . . .*' How could that same voice be a voice of terror that shouted at hundreds and thousands of prisoners, that exterminated them?

He decides to learn Spanish, the language of the country where his father spent his last days, and he studies the geography of Mexico. The name of Veracruz stands out like the mainmast of a sailing vessel shipwrecked on the horizon, against a pale sky. He weaves a shroud round his father's lost body out of the words he gathers looking through books, consulting an atlas and a dictionary; out of a foreign vocabulary he constructs a tomb for that voice forever silenced.

His mother's voice sounds shrill and breathless. It no longer has the warm inflections of the past when she used to relate to him their family legend, nor those crystalline notes that once tinkled in her laughter. The legend is discarded and all happiness ended.

Coming home from school one afternoon, he finds his mother sitting at the table opposite a visitor he has never seen before. Indeed, visits have become increasingly rare in recent months. Thea says, 'This is Franz-Georg.' Then pointing to the stranger, 'And this is my brother Lothar.' Lothar stands up but the boy remains motionless on the threshold. He is completely baffled. What brother? His mother has never mentioned him in the family epic. He has only ever heard – and heard plenty at that – of the two young soldiers whose first names form his own.

The man is tall, fairly heavily built, dressed with sober elegance. Franz-Georg sees no resemblance in him to his mother, grown so slight and wilted. But when the man smiles at him,

he detects a family likeness. In the days when his mother was cheerful and affectionate she had the same smile.

'Lothar has come back from England, where he's been living for twelve years, to meet you,' says Thea. And she adds, 'You're going back with him to London. Your case is packed. It's all arranged.'

She makes this astonishing announcement in a detached tone of voice, her gaze fixed on the grey wall where a portrait of Clemens hangs.

'What about you?' asks Franz-Georg, emerging from his stupor.

'Me? I'm not going anywhere. I'm staying here. The journey would be too tiring for me. I'll join you later, when I'm feeling better.'

But the rasp of death already detectable in her weary voice betrays her pathetic lie. No one is fooled. Her brother and son watch in silence as she absents herself in contemplation of her husband's photograph, or rather the greyness of the dirty wall, the emptiness of her life.

At last she turns to her son and says with a forced smile, 'That scruffy Magnus of yours will be going with you, I've even cleaned him up a bit for the occasion. He's in your case.'

Hearing this, the boy realizes without being able to explain it to himself that his mother had just said her goodbyes, and that any attempt to persuade her to go with them, or to delay or indeed cancel this sudden departure with an uncle who has turned up like some rabbit produced out of a magician's hat, would be pointless. A final goodbye. Having brought him back into the world when he was little by the power of her story-telling, she is now driving him off with the harshness of a few words.

Note

The Schmalker family:

Wilhelm Peter Schmalker, born 1877 in Berlin. Professor of medicine. In 1902 marries Friedericke Maria Hinkel, born 1884 in Zwinkau. Both died in 1945.

Five children were born of this marriage:

- Lothar Benedikt: born 3/5/1904. Pastor. In 1931 marries Hannelore Storm. In 1938 emigrates to England with his wife and their two daughters.
- Paula Maria: 7/2/1905–11/2/1905.
- Thea Paula: born 21/12/1905. In 1927 marries Clemens Dunkeltal (died in 1948 or 1949?). Died in September 1950.
- Franz Johann and Georg Felix: born 18/8/1921. Members of Hitler Youth. Enlisted in the Waffen-SS, took part in several battles. Both died at Stalingrad, in November 1942, within three days of each other.

Fragment 8

Lothar explains to his nephew it would be better if he gave up the surname Dunkeltal that could be damaging to him. He suggests adopting the name of Schmalker, which would more firmly root him in his mother's family with whom he has now been offered a home. And he also suggests choosing another first name, Felix, for instance, an attractive word combining the idea of fruitfulness with that of good fortune. He has had his share of tribulations. It is time for him to start a new life, with a new name meaning 'happy'.

But there is nothing new or cheerful about this name. It was given to Georg as a second name – the boy has a detailed biographical knowledge of his young uncles. It does not much matter that the name did not appear on any official documents and might perhaps never have been spoken, it has nevertheless already been given to a member of the Schmalker family and is therefore fraught with gloomy associations. Franz-Georg points out this detail to Lothar who seems unaware of it, unless he is only pretending. Lothar lets the remark pass, and leaves his nephew free in the end to choose whatever first name he likes. To Franz-Georg this second supplanting of his identity that is being urged on him feels like an assault, and he thinks of his father who juggled with various names and ended up dying as someone called Felipe Gomez Herrera. Grown-ups are truly incomprehensible, and sometimes terribly annoying. After long and glum reflection, he finally opts for a first name of universal currency – mankind's first name, Adam. Lothar congratulated him on this choice.

His aunt Hannelore shows no particular feeling towards this young intruder who has escaped the downfall of Nazi

Germany where at last, thanks be to God, the Dunkeltal couple have come to grief. She observes this undesirable nephew with circumspect and keen attention, anxious to discern what he thinks of everything that has happened, to what extent he has been influenced by his parents. But she refrains from questioning him or even alluding to Clemens' sorry end and Thea's wretched demise, her death coming a few weeks after her son's departure. Hannelore feels a mixture of pity and wariness towards this adolescent orphan who has lost both parents, his country and his name. She doubts it is enough to give a boy of nearly thirteen a new identity, and to drop him into an environment radically different from the one he has always known, in order to cleanse him of the horrors of History with which he has grown up and to console him in his twofold bereavement.

But Adam, silently echoing Hannelore, lets nothing of his own feelings show and never refers to his recent past. The two of them remain on their guard, with questions and things unspoken lying heavy on their hearts.

Yet as the days go by Adam discovers the dark side of the Schmalker family and by extension the hidden face of the Reich that his mother celebrated and his father served with zealous self-abasement. It is Lothar who gradually informs him of the facts, amazed to observe to what extent the child has been kept in ignorance of almost everything, and also how complicit he has been in this false naivety, even if he can guess the reason for it. The time for children's stories is over. Like it or not, Adam has grown up and cannot continue to take refuge in the childhood coziness of not knowing for fear of having to confront the truth.

Reality then finally catches up with him, in a foreign city, in the midst of an emigrant family deeply afflicted by the insane cruelty that has raged in their country of origin and with which some of their own members have collaborated.

And he learns the reasons that gradually led Lothar and Hannelore to flee Germany, taken hostage by Hitler.

One and half years younger than Lothar, Thea had been very close to her older brother until she met Clemens Dunkeltal, a medical student at the university where their father was teaching. The romantic Thea had fallen hopelessly in love with this brilliant scholar who had had to decide between medicine and singing, for which he was clearly talented. As for Clemens, he was primarily flattered by the opportunity to become part of Professor Schmalker's family. The year 1928 was a memorable one for him: he became the son-in-law of an eminent professor and acquired his membership card of the German Workers' National-Socialist Party, led by his mentor Hitler. Thea's parents, of old conservative middle-class stock, nostalgic for the days of Empire and hostile to the Weimar Republic, at first regarded their son-in-law's nationalist fevour with indulgence, and even a touch of pride. Thea herself unreservedly approved of everything her husband said and did. As for the twins Franz and Georg, still little boys at that time, they soon looked up to this martial man with naive and enthusiastic admiration. That left Lothar, the eldest son, whose interest in theology and ethical questions was somewhat at odds with the barbarous political creed belched forth by the author of *Mein Kampf*, which Clemens had warmly recommended to him. His relations with his brother-in-law very rapidly deteriorated, any discussion between them degenerating into an argument, which upset his parents and infuriated Thea. Thus the closeness there had been between the two eldest children of the Schmalker family came to an end.

The discord between them became even more acrimonious when Lothar brought home his fiancée of non-Aryan origin. Hannelore belonged to a Jewish family who came from Bohemia and converted to Protestantism when they moved

to Berlin in 1898. Animosities intensified in 1933 when the Nazi regime tried to curb the country's churches, both Catholic and Protestant, and forced the Lutheran churches to form a united 'German Church' from which all non-Aryans were excluded. A resistance movement immediately started to gather round several strong personalities, Pastors Martin Niemöller, Otto Dibelius and Dietrich Bonhoeffer, giving rise to the 'Confessing Church' and to the organization of clandestine seminaries. Lothar, who had met Dietrich Bonhoeffer in 1925 while studying theology at Berlin university, joined the ranks of the opposition in January 1934. His becoming a member of the Confessing Church – the only authentic one because it preserved the freedom of the Church and respected the real values of Christian spirituality, flouted by the idolatrous and criminal German pseudo-Church that owed its allegiance to the regime – made definitive the rupture with his sister and brother-in-law. Lothar's deliberate separation of himself from his family came as a relief to Clemens who was very much put out by this seditious relative, attached to his Bible like a donkey tethered to its post, and to cap it all married to a Jew.

Each went their own way, Clemens and Thea out in the open to the resounding drum-rolls of the conquering Reich, Lothar and Hannelore aligning themselves with a clandestine resistance whose courage failed to make up for the lack of underground combatants. Intoxicated with promises of glory, or preferring to keep a low profile in the face of a brutal power, the population complied en masse with the prevailing pernicious ideology.

In 1937 the Nazi repression hardened and led to a wave of arrests in dissident circles. Pastor Martin Niemöller, among many others, was imprisoned, summarily tried and finally interned at Sachsenhausen, and then Dachau, and all the parallel seminaries run by the Confessing Church were shut down. That same year the Catholic Church which, not appreciating

the criminality of the Hitlerian enterprise, had signed the Concordat with the Nazi State four years earlier, published the encyclical 'With Passionate Concern'. But the Führer cared nothing for these proclamations of virtuous indignation and just carried right on, crushing any obstacle that lay in his path as he marched towards the podium of savage gods.

Endangered as a dissident, forbidden to engage in any pastoral or educational activity and, even more pressingly, worried for his wife and the future of their two daughters, aged five and three, Lothar decided to emigrate in the spring of 1938. But he was aware when he went that he was leaving a clear field for Clemens, who was a bad influence on Franz and Georg. Wilhelm and Friedericke Schmalker had long since come to their senses and apprehended with increasing dismay to what extent the regime whose rise to power they had greeted with a certain satisfaction was actually based on lies, madness and brutality, but try as they might to warn their two youngest sons the boys would not listen. The already aging parents had lost any degree of authority over their fanatical offspring for whom Hitler was a god, Clemens their role model, and war their vocation.

War, or the delirium of crime raised to the level of a sacred mission. Franz and Georg had joined the Waffen-SS with the faith of young crusaders, and they had ruthlessly killed, burned, massacred in the name of this creed steeped in blood. Franz was killed in combat, in all the glory of his raging passion, but Georg had at that same fatal moment abruptly lost his faith. With his brother's shattered face before him, he had suddenly seen the true countenance of their war god: a piece of torn and bleeding meat. Although this was something that he, death's enthusiastic henchman, had often seen before, he had never attached any importance to it. For him, his victims, dead or alive, had no face. Even the sight of his comrades killed in battle had not affected him so deeply. He had only

one twin brother, Franz, his double, his second self, his own heart's echo. Franz alone could open his eyes by having his mask torn off, that of the supposedly new man, revealing the raw flesh of his poor mortal's face. So this was war, nothing but this, insanely this.

A radical reversal then occurred in Georg. His belief in the superman celebrated by his party all at once evaporated, stricken with inanity, giving way to a faith in man, ordinary man, just as he is in his imperfection and vulnerability. He threw down his arms and refused to take part in any more fighting. This refusal, in which he persisted, was seen as tantamount to desertion, for which he was tried and found guilty, and soldier Georg Felix Schmalker was stripped of his rank, condemned to death and summarily executed.

Clemens, having learned of the affair, strove to hush up the scandal of this shameful end, as much to spare Thea (who with regard, to the twins to whom she bore a jealous love, had long since usurped Friedericke's role of mother) as to avoid damage to his own career. But the family did finally get wind of this secret nevertheless. It gave the parent a little glimmer of consolation in their grief, but Thea denied what had happened and proclaimed her two brothers to be just as united in a heroic death as they had been throughout their lives.

Lothar had vowed to return to Germany as soon as Nazism was defeated, to be at his parents' side at last, and to take part in the rebuilding of his country and particularly of the Lutheran Church. But his parents were killed in the bombardments that brought victory and many of his friends had died, including Dietrich Bonhoeffer, who after two years in captivity had been hanged on 9 April 1945 at Flossenburg, the last camp to which he was transferred. Reduced to ashes, his incinerated body was scattered in the wind.

But the wind over the Reich carried so many human ashes that it bore down with enormous weight on the country in

ruins, a stinking wrap that obscured the sky and suffocated the earth. In the sky of the collapsed Reich extended a vast cemetery, invisible but palpable, being extremely greasy. And in this cinerary sky drifted all the members of Hannelore Schmalker née Storm's family. So for her, it was out of the question to return to that country she ceased to regard as hers. She did not want to live beneath a canopy of incinerated flesh and unconsoled tears – unconsoled, and incurably inconsolable.

Sequence

Only he who cries out in defence of the Jews and the communists has the right to sing Gregorian chant.

Dietrich Bonhoeffer

Death fugue

Black milk of first light we drink it in the evening
we drink it morning noon and at night we drink it
we drink and drink
we dig in the air a grave not cramped to lie in
A man lives in the house he plays with snakes he writes
to Germany when it darkens over he writes your golden hair
 Margarete
he writes and steps out and the stars glitter he whistles up his
 hounds
he whistles out his Jews to dig a grave in the earth
he commands us strike up for the dance . . .

He shouts sweeten your playing of death, death is a master
 from Germany
he shouts darken your strings then as smoke in the air you'll
 rise
a grave in the clouds you'll have a grave not cramped to
 lie in . . .

death is a master from Germany
your golden hair Margarete
your ashen hair Shulamith

Paul Celan, '*Todesfuge*'

Fragment 9

Adam has pieced together one part of the family jigsaw puzzle that is much more like a painting by Otto Dix, George Grosz or Edward Munch than the romantic picture his mother presented to him. But this puzzle still remains very incomplete. There is a gap surrounding his early childhood and Lothar is unable to help him fill it since his uncle left Germany the year he was born.

He learns English quickly, but without experiencing the same emotion that Spanish affords him. He pursues the study of both languages simultaneously, one out of practical necessity, the other because of an inner need. He has set up Spanish as an absurd talismanic goal: he is determined to gain a perfect command of the language of the fraudulent Felipe Gomez Herrara in order to gain ascendancy over the ghost of that assassin whose crimes remain for ever unpunished, and over the loathsome charm to which he, the deceived abandoned son, above all the son unbearably tainted by this kinship, is still susceptible. It is no longer a tomb for the suicide's body that he wishes to build with this language but a fortress in which his father will be eternally confined. In fact he wishes he could dissolve his father in the words he aggressively masters, as though in acid.

As for his mother, he is unable to locate her precisely in the irregular geographies of his heart. He thinks of her in a turmoil of tenderness, resentment, anger and pity. He thinks of her often, so often he cannot accept the idea he will never see her again.

She had indeed cleaned up his scruffy teddy bear before stuffing him into the suitcase, just as she told him on the eve of

their parting, but this cleaning-up turned out to be more a curious kind of mending. Magnus's golden-yellow buttercup eyes that gleamed with gentleness have been transplanted to the soles of his feet and fixed in their place are two colourless but very sparkling little crystal roses. After a moment's surprise, then uncertainty, Adam recognized these roses of glittering transparency: they were the diamond earrings Thea used to wear in the days of those splendid dinner parties and musical evenings in the house on the moors. The little boy he once was would marvel at their brilliance, like gleams of moonlight in his mother's ears, suffusing her face and blonde hair with astral brightness. She brought them with her when they fled, along with all her other jewellery, to raise cash if need be. Since they were forever in need she must have sold off all her bits of treasure but these two perfect diamonds she had kept. Now they shone in Magnus's face, two faceted beads, devoid of colour and above all of reverie. The eyes of a monstrous fly, blind and blinding.

Adam had a sudden impulse to tear off those obscene diamonds disfiguring his bear, but just as he was about to act on it his hands dropped: it was if he were about to do violence to his mother, to remove her eyeballs. He contented himself with removing from the bear's neck the kerchief embroidered with the name Magnus, to blindfold him with it. On examining the buttercups ridiculously pinned to Magnus's feet, he finally realized they too were a pair of earrings; much more modest pieces of jewellery, of a gold and copper alloy. Did his mother wear these when she was a young girl, before she married Clemens and appropriated jewellery stolen from the women assassinated by her husband in the camps?

He wrapped Magnus up in a cloth and hid him at the back of the wardrobe in his bedroom.

As soon as his level of English was sufficient to attend normal classes, his uncle enrolled him in a school as a boarder. So he

spent most of the time away from the Schmalker family and his relationship with his two cousins, Erika and Else, five and three years older than him, remained distant. He preferred the younger, a small brunette of mischievous charm with already a lot of admirers. Erika by contrast inspired in him mixed, indeed rather painful, feelings so much did she resemble Thea – the aunt having circumvented the mother to pass on to Erika her fair hair, sharp features, and even the inflections of her voice. But the young girl inherited from Hannelore her taciturn character, solemn gaze, and reserve. This web of similarities even extends to her choice of fiancé: a young man from the emigrant German community in London who is intending to take up the same pastoral duties as his future father-in-law, just as the medical student Clemens Dunkeltal formerly followed in the footsteps of Professor Schmalker, very soon to branch off in a completely different direction, it is true, going so far astray he became totally mired.

Among Else's girlfriends, who all excite his curiosity, one in particular captures his attention, a very curly redhead called Peggy Bell. What attracts him about this mercurial young lady are the little physical oddities of which she feels ashamed and that he finds enchanting, such as the sprinkling of freckles on her cheekbones and upturned nose, the dimple that appears in her left cheek whenever she smiles, the slight cast that imparts a look of perpetual surprise to her lime-green eyes, and her hands and feet, as small and plump as those of a little girl.

But this little girl is seventeen, and she is impudent. One summer afternoon when visiting the Schmalkers, finding herself momentarily alone with Adam in the drawing room, she leaps up from the chair in which she was sitting, and comes and stands right in front of him, an adolescent boy of nearly fifteen and all the more gauche for being in a confusion of desire, and asks him point blank, 'Am I pretty? Tell me honestly, do you think I'm pretty or not?' He is left speechless. She pretends to be offended, and he, incapable of responding

with a compliment, of uttering the slightest word, or of smiling, grabs her in his arms and kisses her on the mouth. At the touch of her warm lips, her soft breasts against his chest, her body, all curves and youthfulness, he suddenly feels welling up inside him a rush as powerful as that he experienced with euphoria and amazement one day already long ago on the banks of Lake Constance, at the sight of the dual conflagration of sky and water during a storm. His kiss and his embrace are as fleeting as the gigantic flash of lightning was that day, and their effect just as intense. Then with the same abruptness with which he drew her close to him, he pushes her away and flees the room, red with shame, leaving Peggy dumbfounded.

This stolen kiss is to release in him over the coming months a succession of dreams that sometimes waken him with a start in the middle of the night, his belly wet with a milky whiteness. In each of his dreams he sees Peggy Bell coming towards him, sometimes laughing, sometimes looking cross, playing with her skirt, whose folds swing, dip and twirl, then drop down, all starched and well-behaved, only to start up again, twirling round. This game goes on for some time until Peggy catches her skirt by the hem and all of a sudden lifts it up. Lifts it up very high, baring her knees, thighs, belly. She is not wearing any knickers, she has just a little russet sun whose rays ripple over her extremely white skin. Sometimes the sun revolves, sometimes it turns into an orange-coloured thistle, or a chestnut-burr. But what exactly is inside the burr?

Erika gets married, and the following year it is Else's turn, then Peggy Bell's. So someone other than Adam has assumed the right to penetrate the secret of Peggy's body, a certain Timothy McLane. Someone else, and not he, is going lay hold of her belly and her breasts, the little russet sun blazing between her thighs. Another. An interloper. Not he.

On the night of the wedding, overcome with suppressed fury and resentment, knowing he has been robbed of his

47

dream, Adam does what he has never yet dared, and thought himself incapable of daring to do – he seeks out a prostitute. So, while Peggy takes off her white dress in some honeymoon suite and prepares to yield her virgin body to her husband, Adam in a short-stay hotel room watches some unknown woman with dyed hair undress with routine gestures and present to him her already faded body. She lies on the bed and spreads her legs. And there he has done with his virginity, with his dream of a sun of silk-soft warmth. He has done with his false innocence and his batch of naive images, but not with the strength of his desire that on the contrary becomes still more ardent.

The Schmalker house, to which he continues to return for all the holiday periods, seems very empty to him now. With the perfume and laughter of the young girls gone there is a drabness that now prevails. From time to time faint cries and mewlings are to be heard, those of Erika's daughter, Myriam, when the young woman visits her parents with her baby. This is the first baby Adam has ever seen, for though as a child during the exodus he observed a lot of dead bodies along the way he has never before laid eyes on a newborn infant, and the sight amazes him. Myriam is a tiny creature with brown hair stuck to her head, her frog-like bulging eyes shut, little fists tightly clenched, a mouth greedy for milk and ready to complain. He dare not take her in his arms, her fragility terrifies him, her smell repulses him, her whimpering irritates him. But he bends over her when she is lying in her cradle and studies her at length, disturbed by this strange mixture of purity, daintiness and delicacy, and pathetic toad-like ugliness when the little face screws up and convulses as a result of hunger or some other vexation, the face of a miniature old man with diaphanous satin-like skin concentrating on some ancestral wisdom much too vast for his still unformed mind. He himself, he reflects, was like this baby, like some nacreous-hued

ancient sage full of age-old knowledge, quivering with comfort in the maternal arms, with repletion on the maternal breast, with light in the maternal gaze, and imbibing, from his mother now dead, her milk, smiles, and tender words, her caresses and her smell. And he suspects this cannot have totally disappeared, that this original love must be dormant deep in his flesh. In far-off days her milk nourished him, her smiles quieted him. And her softly sung words wakened him to the world; her caresses, to his own body; and the clearness of those maternal eyes, to the beauty of the day. Maybe, in days yet to come, this love lying dormant in the darkness of his heart will raise its auroral face to cast light on him at last, to help him forgive all those crimes with which, out of pride and tragic stupidity, that foolish mother of his colluded. Maybe.

And he holds his breath on the brink of this maybe, before the infant snuggled in her cradle, before the enigma of that body, so tiny and vulnerable and yet supreme, absorbed in the sound of its own blood in which there yet murmurs the entire memory of the world, the universe.

Hannelore always behaves towards him as a considerate but distant host; Lothar, as a tutor primarily concerned for the sound academic, moral and religious education of his nephew. But offering no emotional guidance whatsoever. His feelings are unruly, he does not know what he likes, or what he wants. He does not know how to love. From time to time, whenever he can, he goes with a prostitute, but his heart rings hollow.

This is what it comes down to: the Schmalkers are tutors carrying out their educational duty as best they can. For Adam is well aware he is an outsider grafted on to his uncle's family, a refugee twice over under the roof of emigrés. He is not their son and never will be. Worse, he remains the offspring of a cowardly killer and through her stupidity and vanity a criminal by association. His powerlessness to wipe out this sickening ancestry, or at least call to account the parents he loved

with an innocence he now deems culpable, translates into a violent animus towards himself. This bitterness inwardly chokes him, and as he emerges from adolescence sculpts his features with harshness.

The puny child he used to be, owing to years of poverty in Friedrichshafen, becomes at eighteen a young man of medium height with burly shoulders and a rough-hewn face. His hair has darkened to a shade of walnut with coppery glints and his once winsome curls are now shaggy and unkempt. His forehead is broad and prominent, his eyebrows are bushy circumflexes, and there is a bronze-tinged smokiness to his deep-set light brown eyes. He has high cheekbones, a flat nose, full lips, the upper one slightly projecting, and a square jaw. None of the prettiness of his mother or the imposing aspect of his father in their younger days. There is something of the bear and ram about him.

Note

BEAR: Like all large wild animals, the bear is one of the symbols of the chthonian unconscious – lunar and therefore nocturnal, deriving from the inner landscapes of the earth mother.

Many peoples regarded the bear as their ancestor. In Siberia until a short time ago there were still graveyards for bears.

For the Yakut of Siberia the bear *knows everything, remembers everything and forgets nothing*. The Altaic Tartars believe *the bear hears through the medium of the earth*, and the Soyot say, *the earth is the ear of the bear*.

In Europe the mysterious huffing of the bear emanates from caves. It is therefore an expression of darkness, of gloom; in alchemy it corresponds to the blackness of the primary state of matter. Darkness and the invisible being associated with that which is taboo, the bear's role as initiator into the arcane is thereby reinforced.

RAM: The ram is a cosmic representation of the animal force of the fire that erupts dramatically, explosively, at the earliest moment of materialization. This fire is both creative and destructive, blind and rebellious, chaotic and prolonged, prolific and sublime, and from a central point spreads out in every direction. This fiery force relates to the inceptive surge of vitality, the primordial impulse of life, with all that is pure crude urgency in such an inchoate process, all that is ebullient, zestful, indomitable energy, dynamic excess, fervid animation.

Jean Chevalier and Alain Gheerbrant
Dictionary of Symbols

Fragment 10

Since he has a great facility for learning languages and still nurtures an obscure passion for Spanish, he chooses to study Romance languages at university, Portuguese and French as well as Spanish. In fact he is especially gifted with an extraordinary memory, having diligently trained it from the age of six as a defensive reaction to the loss of all his memories of early childhood. He can instantly memorize every new word he reads or hears. This retentiveness also applies to anything visual. But while this excessive memory might be an advantage in his studies, it is also a burden to him. His memory remains active without respite, registering the slightest detail, letting nothing go. It torments him even at night, fomenting in his dreams a riot of images and words with an exactitude that sometimes wakens him with a start, so razor-sharp is it. He then has the impression of a rift in time, of past and present colliding, running into each other, overthrowing the sequence of events. Coexisting inside him, intact, unbearably vivid and enduring, is every moment of his life since the age of six. It is therefore impossible for him to mourn his parents, to distance himself from them, from their lies, their madness, their crimes. And their ill deeds oppress him with shame, sadness, and anger, they contaminate his body, imprison his youth. They hold his heart captive. He is the posthumous hostage of two predators whose death now guarantees them eternal impunity, and therefore a perpetual injustice to him. Whether or not there is any judgement to face in the hereafter does not concern him. It is here and now, before the world, that the mortified son would like to make his parents pay, and particularly his father.

At the end of his third year of studies, he goes to Mexico for

five weeks. This is the first journey he has made since emigrating to England and his first foray outside Europe. He goes off on his own to encounter, by himself, a country and a language that as yet he only knows through books and that torment him with caustic desire.

When he arrives in this country he has the sense of finally meeting someone in the flesh after years of only hearing their voice. He encounters the vast, rugged, magnificent landmass of the language in which the bogus Felipe Gomez Herrera was entombed. After ten days in Mexico, he sets out for the state of Veracruz. He does not know what exactly he hopes to find there. He has no knowledge of where his father lies, or even if he was buried or cremated. He knows no one who could tell him about the fugitive's last hours. His mother had announced only the brutal fact: the death of Clemens Dunkeltal by his own hand, with no other explanation. Then she had immured herself in her despair, so worn down by loneliness that little by little she died of it. So he wanders first of all through the town of Veracruz, its suburbs, port and shipyards. Sometimes he stops in the middle of the pavement, examines the facades of the houses, wondering if his father lived there, perhaps hid there. Or walking on the quayside, he watches the ships, one of which might in the past have carried the absconder. He scans the dark waters glinting with greasy brilliance in the harbour where rather than face justice that bastard, on his last legs and down to his last cent, maybe threw himself in. He juggles all day long with such hypotheses but settles on none of them.

One evening, while drifting along in this way, he notices a woman walking down an avenue in front of him. Her step is confident, she has black hair plaited in a long thick braid, and terrific legs. Forgetful for a moment of his ruminations, he follows her for the sole pleasure of observing this figure that moves likes a dancer.

At one point the woman steps off the pavement to cross the road, but hardly has she set foot on the highway than a car she has not seen comes speeding towards her. Adam rushes forward and manages just in time to grab her by the arm and pull her back. The reckless driver goes hurtling by, indifferent to the accident he almost caused. The woman is thoroughly dazed by the shock and the roar of the car, Adam is breathless. Eventually she says to him in English with a strong American accent, 'Thank you, I think you just saved my life . . .' Then, recovering herself, she repeats the same phrase in Spanish, searching for her words.

The beautiful passer-by is Mary Gleanerstones. She comes from San Francisco and is spending a few days in Veracruz, accompanying her husband on a business trip. She absolutely insists on introducing Adam to Terence, her husband, whom she was on her way to join at their hotel, and she invites him to have dinner with them.

The Gleanerstones are older than he is. Mary, who calls herself May, is about thirty, and her husband close to forty. His dark chestnut hair has gone completely white at the temples, and the whiteness of these two little wavy wisps soften his irregular-featured face. In the course of the evening Adam detects in Terence a discerning eye and delicacy of attention, ever alert behind his easy-going manner and sense of humour, and in May a mixture of toughness and passion, impatience and determination, pride and irony. With dark eyes, a very straight nose, strong widely-spaced cheekbones, her face is flawless, like a mask of ochre-coloured wood. She owes her complexion and her features to an Indian ancestress of the Omaha tribe who, she says, has declared herself after three generations, eclipsing with quiet insolence May's other blood-lines, Hungarian, Scottish and Ukrainian.

Adam does more listening than talking, impressed by this couple so much more mature than he is, and above all who

move in a world so different from his own: an active and open world where everything seems easy: money, travel, relationships, the art of conversation. He can tell they have a very close relationship, more like that of siblings than lovers, making their presence as straightforward as it is generous, and he enjoys their company. For the first time in his life he feels secure. However, he says nothing about the true reason for his having come to Veracruz, nothing of his German childhood. He has presented himself as an English student on holiday and he evades any questions about his family.

At the end of their meal May searches in her handbag and pulls out a book wrapped in a paper bag. 'This is a novel by a Mexican writer that came out two or three years ago – someone spoke to me very enthusiastically about it,' she explains. 'I bought it today but my level of Spanish is much weaker than yours, so I'd like to give the book to you. When you've read it you can tell me whether it really is worth making the effort to tackle it in the original, as was suggested to me.'

To reinforce this reason for getting in touch again, Terence slipped his card into the bag, having written on the back of it the details of their hotel.

Back in his hotel room, Adam opens the book. It is a copy of *Pedro Pàramo* by Juan Rulfo. As it is already very late and he is feeling tired, he is content to leaf through the book and pick out odd sentences at random. But Juan Rulfo's novel does not lend itself to idle skimming, it awakens Adam's drowsy attention and keeps it riveted. He reads straight through to the end the story of Juan Preciado and his search for the father he has never known, a certain Pedro Pàramo, who ruled the village of Comala as a petty dictator, consumed with ambition and the taste for power. But Comala now is a forsaken village beyond the compass of time and life, baked white beneath a deadly sun – '*You're on the earth's burning coals there, in the very mouth of hell.*' For all is dead in Comala, and Rulfo's tale is

a strange polyphonic dirge, an interweaving of the stray plangent voices of ghosts.

Adam keeps reading and rereading the book to the point of exhaustion. Until he is not just reading any more but entering into the book, walking through the pages, through the streets of the deserted village. He walks in the footsteps of Juan Preciado, the son in search of his father, now dissipated in the burning dust of Comala on whose walls, the colour of bone, glance the voices of the deceased, continuing to speak in their absence, to dwell on memories of those wretched lives they have long been departing.

He walks in the footsteps of Juan Preciado, but following hard on the heels of the latter is a cohort of ghosts reduced to echoes, and these ghost voices resonate inside his own head.

Juan Preciado is his double, his guide through the ruins of memory, the labyrinth of forgetfulness. And Pedro Pàramo, the odious provincial caudillo, a brutal and arrogant man, is Clemens Dunkeltal's projected shadow in Comala, a village to be found everywhere and nowhere, a haunting place of no precise location. A charnel-house village exuding echoes, cries and groans, a mirage village at the crossroads of the living and the dead, the real and the imagined.

Sequence

You'll feel even hotter when we get to Comala. You're on the earth's burning coals there, in the very mouth of hell. They say a lot of those who die there and go to hell come back to fetch their blanket . . .

This town is filled with echoes. They sound as if they're trapped inside the cavity in the walls or under the paving-stones. When you walk you sense them following in your footsteps. You hear rustlings. Laughter. Time-worn laughter, as though weary of laughing. And voices wasted through use. All this you hear. I think the day will come when these sounds die out.

Juan Rulfo, *Pedro Pàramo*

Fragment 11

It is barely light when Adam starts out. He leaves town with the book deep in his pocket. He sets off for Comala.

He strikes out westwards, at random, leaving the coast behind him. He passes cotton fields. He sees the sky turn rosy where it meets the orchards. He walks with his back to the sun. His shadow is still pale, unclear.

He strides across unknown territory, chasing a ghost. But whose? That of Pedro Pàramo, Felipe Gomez Herrara, Clemens Dunkeltal, Thea, or himself? He does not know any more. In any case, the ghost flees.

He is bound for Comala, for nowhere, for a meeting with himself. His progress is erratic, frantic. He is an angry pilgrim come to throttle the paternal ghost and that of the naive child he once was who loved his father. But the ghost keeps giving him the slip, defying him, wearing him out, and in the process his anger intensifies, distills. His shadow lengthens, darkens.

He knows his quest is absurd, doomed to failure, but he does not relent. He senses something developing. Something indefinable. Weird and yet powerful. Between him and this place. Between him and this moment on the fringes of time. And what is conspiring inside him unsettles his memory, looses its moorings, and gradually sends it into a spin. The spinning gets faster.

Thousands of images run backwards before his eyes, just as a dying man sees his entire past go flashing by.

The heat is intense. He has been walking for hours. His shadow has narrowed, condensed: a black puddle at the tip of his shoes. He has not slept and has eaten nothing since the day

before. All of sudden he is drained of strength. He sits at the edge of a field on a bare slope. The sun beats down, as torrid as it is high in the sky. He stretches out on the ground, overcome with dizziness.

There he lies on the earth's surface, in direct contact with the landmass of his father's language-shroud, the language acid-bath that will dissolve forever the sickening remains of his love for that father. But no, Spanish is not the language of this land. It is not indigenous. It came from outside just a few centuries ago, imposed by force of arms. A more ancient language frets beneath the stones, the dust. The language of the vanquished, unyielding, intractable.

And slowly yet another sound becomes audible. It emanates from all around, from the earth and the air, from the stones and the grass. It is a harsh haunting song that soon swells, expands, vibrates.

The song assails the phantom-chaser's spent body. It is the chorus of insects in the pulsing heat of noon. A multiple voice. Monotonous. Voracious. The broiling air squeals and sizzles. The ground emits faint stridulations, low hummings. The insects embroider the silence of the sun-sated earth with their stubborn little voices. On the surface of emptiness they attend to their tiny destiny. They score this incandescent time of day with vocal striations as though to leave a trace of their presence no one cares about, to prove to themselves they exist, and to enjoy as much as possible their short spell in this world. Song of euphoria, desolation and combativeness. Song of the living. Of beast and mankind.

And all of a sudden, what was conspiring in his fevered brain just now as he staggered beneath the sun explodes in his body stretched out on the ground, riddled with the cries of insects: a tidal wave of vibrant visions sweeps through him. But his

father does not figure in any of them. The rush of jolted memories that overwhelm him rise from elsewhere, from further back; it is an upsurge originating in the middle of the night that he died – he, Adam Schmalker, before he took that name, and even before he was called Franz-Georg Dunkeltal.

Long, long before.

Before. In the quick of the present moment.

He hears the bellowing of a monumental organ, deafening clashes of cymbals, the roll of millions of drums. An insane orchestra plays in the sky. It plays with instruments of steel, of fire. The tumult even reaches underground, and the ground quakes and screams.

It is a discordant choir of men and women of all ages, children, infants, dogs, screaming in response to the orchestra's din, and this choir that was huddled close together underground suddenly disperses in a frantic rush. Its clamour spills out into the open, scatters across the face of the earth, fragments. He is one of the fragments of that pulverized clamour. He runs, shrieking and crying.

He sees the sky combust, burst like a dyke and torrents of black lava, blazing meteorites, sulphur-white flashes of lightning pour through the cracks. The insane orchestra is playing with fire, in a total frenzy.

He sees human beings and animals turn into live torches, others melt into the liquefied asphalt slushing in the gutted streets, and yet others blown apart.

He sees trees rise up in the air at an angle, enormous flame-trailing javelins that plunge into the fronts of houses while windowpanes shatter, chimneys, tiles and beams go flying.

He sees water blaze in the harbour, in the canals, rivers, ponds, gutters. Everywhere water catches fire and evaporates with a hiss. It ignites even in the tears on the faces of the distraught, of the dying.

He smells the acrid stench of burnt flesh, the nauseating sweetness

of boiled flesh, the stink of blood and guts. Stones, pavings, timber frames are reduced to no more than black sand, gravel, bits of charcoal.

He sees coils of garish yellow, spills of bright red, splashes of blinding orange falling from the sky, lacerating the darkness. An orgy of colours at once viscous and limpid. Gigantic gobs of scarlet and gold to crown the perished city.

He hears the gobs of colour rumble and suddenly among the dis-jointed puppets running in all directions he sees a woman engulfed from head to toe in saffron flames dance a frenetic solitary waltz, emitting piercing screams. He sees her collapse, writhe for a few seconds more and . . .

And then nothing.

That's all. He sees and hears nothing more, just that torch-woman reduced to a shapeless heap of reddening black that smokes and stinks. His mother? A fairy? A witch? A tree-trunk? A lightning-struck angel? A stranger?

He watches her. Watches her burn to a cinder. With eyes wide open, he watches her disappear from sight, disappear from his life. With eyes wide open, eyes blinded, he watches and watches . . .

Note

The mouth of hell is the orifice by which mankind is swallowed up – and here we recognize the famous theme of the descent into Hades. It is also the place from which voices emerge . . . The echo is a form of sound inscribed in time and produced in certain contexts favourable to the reflection of an original sound . . .

The future of an echo is a wall, an obstacle, a sentence of death. The echo impacts with something that sends it back into the past. An echo is a moving sound but one that travels backwards, with no hope of ever becoming other or different; its destiny is extinction.

Fabienne Bradu, *Echoes of Pàramo*

Fragment 1

Hamburg. The hour of Gomorrah.

The operation of destruction strove to prove itself worthy of this title of devastation. In the warmth of a summer's night it staged a monstrous opera in so rapid a sequence of acts they were indistinguishable one from the other.

'*Then the Lord rained upon Sodom and upon Gomorrah brimstone and fire from the Lord out of heaven; and he overthrew those cities, and all the plain, and all the inhabitants of the cities, and that which grew upon the ground.*'

Among the inhabitants is a little boy of five and a half. He is asleep, curled up round his teddy bear, in a cellar crowded with people. But the cellars are derisory shelters, rat traps when everything caves in on top of them, and the survivors rush to escape from the hideout strewn with shattered bodies. They flee into streets lined now with nothing but stumps of smoking walls. Distraught and shrieking, they go running to add to the uproar of Gomorrah, where screams keep rising from here and there, suddenly falling silent to resume elsewhere – other screams yet always alike.

The little boy, wrenched from sleep, runs without comprehending anything, and mingles his crying with the great ambient din. His crying turns to sobs when the hand that was holding his suddenly lets go. He is alone in the crowd, all alone in his nightmare. For he is still asleep, asleep on his feet, running and crying. But his crying suddenly ceases when he sees the woman who was holding his hand start to waltz in the mud and ruins with a great bird of fire fastened on her back. The predator spreads its radiant wings and envelops the woman in them from head to foot. Before this abduction of amazing speed, of fierce beauty, the little boy swallows his saliva like a

stone, in the same gulp losing all the words, all the names he ever knew.

Hamburg, the moment of obliteration.

'*And Abraham . . . looked toward Sodom and Gomorrah, and toward all the land of the plain, and beheld, and, lo, the smoke of the country went up as the smoke of a furnace.*'

The child is not Abraham, just a little boy clutching his teddy bear very tightly to his chest, and his gaze splinters. Death takes him alive there, before the furnace, leaving him dead to his memory, to the language he spoke, to his name. His soul is petrified, his heart condenses into a block of salt. In counterpoint to the celestial conflagrations and outcry of the shattered city, he hears the thud of his salty heart beating inside the fabric body of the bear whose muzzle is crushed against his throat, whose buttercup eyes are pressed to his neck. The heat all around is suffocating, the air thick with sooty dust and gas. Only the teddy bear's eyes seem to have preserved a miraculous clarity and gentleness.

Hamburg, zero hour.

'*But [Lot's] wife looked back from behind him, and she became a pillar of salt.*'

In this temporal gap a little boy who has only just died is brutally delivered back into the world, cast completely naked into one of the world's craters. He knows nothing about himself any more. He cannot distinguish between his own body and that of the teddy bear with rununculus eyes. He now knows nothing about humanity, he confuses the human voice with the tumultuous din – of explosions, of avalanches of stones, beams and metal, of the forest of flames sweeping across the demolished town, of the wails of the dying and the screams of deranged survivors. He knows nothing any more of his language. Words are but sounds chaotically crowded

into the furnace-press of war, producing a slimy run-off stinking of blood and carbonized flesh, of sulphur, gas and smoke. A greasy black run-off streaked with glittering gashes of yellow and scarlet.

Hamburg, daybreak following Gomorrah.

Brought into the world by war, all alone among the ruins, the newly reborn child confuses beauty with horror, madness with life, melodramatic horror with death. He sets off, like a bundle blown before the wind, carried by the tide as droves of survivors flee the fine city steeped in waters of chastisement for crimes committed by the Reich.

When people finally show some concern for this evidently lost or orphaned child walking along in a trance, he cannot answer any question put to him. He is thought to be deaf or simple-minded. Someone has the idea of untying the scorched handkerchief round his teddy bear's neck. There is a name embroidered on it in multi-coloured threads: Magnus. Is this the name of the teddy bear, the child's father, or the child himself? For want of a better alternative, the young deaf-mute is given this name. And under this borrowed name he is placed in a centre with other unclaimed children waiting for adoption or foster families.

After Gomorrah, on the verge of the moor, on the steps of hell.

A woman turns up at the centre. She inspects all the children. A woman still young, elegant, but her face hardened by a recent bereavement. The story of this little boy, not a deaf-mute but with no memory whatsoever, interests her. She observes him for a long time, finds him cute, placid, and suspects he is intelligent. He is a curly-haired little boy, with hazel eyes, a skull that perfectly conforms to Aryan standards, and uncircumcised. Sound in body and sound in race. As for

his mind, it has been denuded, a rubbed-out page ready to be rewritten. The woman will undertake to make it totally blank before writing on it to suit herself. She has a substitute text for it. A text of revenge against death.

Notes

At the height of summer 1943, during an extended heatwave, the RAF, supported by the US Eighth Air Force, flew a series of raids on Hamburg. The aim of this offensive code-named Operation Gomorrah was the maximum possible destruction and incineration of the city. In the course of the night raid that began at one o'clock in the morning of the 28th July 10,000 tons of high explosive and incendiary bombs were dropped on the densely populated residential area east of the Elbe . . .

W.G. Sebald, *Luftkrieg und Literatur*

For anyone who likes records, who wants to become an expert in ruins, and wants to see not a town in ruins but a landscape in ruins, more of a wilderness than a desert, more desolate than a mountain, and as phantasmagorical as a nightmare, there is perhaps after all only one German city that answers: Hamburg . . .

Every geometrical form is represented in this variant of Guernica and Coventry . . .

Stig Dagerman, *German Autumn*

Fragment 12

A victim of sunstroke, the young man found unconscious on the edge of a cotton field is taken to a hospital in Veracruz. For two days his body and mind are in a sweltering fever. He sweats, he tosses, he raves. But beneath his sun-burnt eyelids, his gaze is fixed, arrested on an image, that of the black mass the woman turned into after twirling round, her back winged with flames. He wishes he could see her face as it was when she was still alive, the face she had in the cellar, in the street in ruins, just before the waltz. He wishes he could rewind the sequence of images, but his memory refuses to. Brought up short by this carbonized body, his memory disintegrates, excoriated and exasperated.

When at last, by force of tension, his memory restarts it moves the other way, running forward. Out of the dark mass lying in the mud and ashes he sees another woman rise, a stranger dressed in a black suit, her mouth painted red, her ears sparkling. She comes towards him, with her red smile, shining eyes, and crystal flowers glinting in her ears. She bends over him. She smells good. She strokes his head, murmurs words he does not understand but they rustle like foliage, then she takes him gently by the hand and leads him away. He follows her, like a meek little robot, but when the woman tries to make him part with the teddy bear he is clutching under his arm, he escapes from her with piercing screams. She has to submit to letting him keep this ugly relic of his past which she intends to get rid of as soon as she has won the child over.

'Magnus . . .' he says, repeating this name several times in an enfeebled voice before he finally opens his eyes. His fever has

dropped and slowly he regains consciousness. He sees a woman sitting at his bedside. At first he does not recognize her. She did not appear in his visions. It is May Gleanerstones.

When the patient arrived at the hospital, all that was found on him was the novel by Juan Rulfo and Terence Gleanerstones' visiting card, no other document. So a call was put through to the hotel number written on the card and the Gleanerstones came at once, but they could not provide much information. They only knew the young man's first name and were not sure of having correctly remembered his family name. They were puzzled to hear this English student speaking German in his delirium. They also thought he occasionally uttered some phrases in yet another language, but were unable to identify it.

The new book May had given him was already very much the worse for wear. It was obvious from its dog-eared and in some places crumpled pages that it had been handled without care, avidly read and reread. Without any further hesitation she started to read the book herself, her imperfect knowledge of Spanish galvanized by curiosity. The narrative disconcerted her, with no other characters but souls in torment tossed about in the void, interweaving snatches of dialogue, a whirligig of echoes escaped from beyond the grave and wandering like fireflies through Comala's long sleepless night. 'Is this how the dead speak to us?' she wondered. Terence replied indirectly, saying this is how memory speaks to us, in a continuous repetitive undertone, so low, so indistinct, like that of the blood in our veins, we do not hear it. But there are books written in such a way that at times they have the effect on some readers of those big shells you can press against your ear and suddenly hear the sound of your own blood quietly roaring in the conch. The sound of the ocean, the wind, your own heart. Sighs from limbo. Adam has read this book, one that, for others, tells only a strange confused story they cannot get to grips with, and it is as though he had put the book to his ear. A hollowed-out,

furrowed, bottomless pit of book in which a plethora of echoes started whispering.

Unable to wait for the young man to regain consciousness, Terence had to return to San Francisco for business reasons. May stayed behind, feeling close to this stranger lying in a hospital bed. What a peculiar lad though! He saves her life, and the next day puts his own in peril by going out walking, bare-headed, in the sun because he is completely obsessed with a book he has read. However, this book is one she gave him, so she feels partly responsible. Mainly, she is extremely intrigued by this young Englishman. So reserved when they had dinner together, in his delirium he speaks, shouts in other languages. Finally, something she dares not really admit to herself, she is even more attracted to this young man for having seen him fight his demons in bed, his hair damp with sweat, his breathing throaty, as in lovemaking. And she wants to take the place of those demons he had to contend with in his fever, and lie with him on a bed, smell him on her skin, feel the entire weight of his body on her own, hear his heavy breathing on her neck.

'Magnus? Who is Magnus?' asks May, leaning toward Adam.

'I am,' he says.

'And Adam? What's become of him? Has he stayed behind in Comala?' she continues, sensing the young man has lost himself in the book, but not really knowing whether his mind is still wandering or he is talking sensibly.

'Since you've read the novel, you know that Juan Preciado is in fact already dead when the story begins. Well, in my own way I too was dead. Adam Schmalker was a delusion. It was natural he should collapse on the edge of the slope, and evaporate in the sun. It had gone on only too long.'

This reply leaves her perplexed for she is not sure she quite follows its skewed logic, but she is in no further doubt this decidedly disconcerting young man is in full possession of

his wits, indeed that he has acquired greater lucidity in his wandering delirium.

'I have the bizarre impression of understanding what you are going through and at the same not understanding at all,' she says eventually. 'When you're completely recovered I'd like you to explain to me who you are.'

He smiles with a weary bitter expression for he too, more than anyone else, would like to know who he is. For the time being, he only knows who he is not, never was and will never again believe himself to be: the Dunkeltals' son. A deliverance. But he feels bereft – of his borrowed name, his false relationship – with the name of a teddy bear for his sole substituted identity. A name that as in the past he assumes for want of a better.

Magnus. Alias Magnus. By this fanciful designation he decides to enter at last the age of manhood.

Sequence

'My mother,' I said. 'My mother's dead.'

'So that's why her voice sounded so weak, as if it had to travel a great distance. Now I understand. And when did that happen, that she died? . . .

'Oh yes, I came close to being your mother. She never told you anything about that?'

Juan Rulfo, *Pedro Pàramo*

Fragment 13

Magnus's body, the smell of his skin, the taste of his lips, the throatiness of his breathing in the climax of love-making – May soon has enjoyment of these pleasures. She falls hopelessly in love with this young man eleven years her junior. It is this difference in age, and the fear he may one day lose interest in her in favour of younger women, that makes her apprehensive, but what she fears most of all is the strength of her physical attraction to him, her insatiable and jealous desire. She feels pinioned by this violent longing for him, enthralled by this unexpected love that has completely taken possession of her. She has always set out to be strong, free from all constraint. She has had many lovers since the day she married Terence at the age of eighteen, but none has ever conquered her in such a way before. She was always able to remain in control of the situation. But now she is defenceless. However, she has enough pride and shrewdness not to betray to Magnus the state of dependence to which he has unwittingly reduced her. With charm and gaiety she does her utmost to retain her allure for him.

Magnus in fact has no inkling of how hard May is battling against the passion he has aroused in her, and he himself is not allowing full freedom to his own amorous feelings for he cannot envisage a lasting relationship. The Gleanerstones seem to form too close a couple to leave room for anyone else. But these fears of delusion and heartbreak are groundless since Terence is May's husband in name only. He is a very chaste spouse, she explains with laughter, and very accommodating, because he prefers men, and has affairs only with male lovers. Their marriage is a contract that has satisfied both of them since the outset. A very flexible contract, based on respect and

affection, strengthened over the years by a deep mutual under-standing. Terence and May are cousins. This marriage offered one of them the cloak of respectability required by his social class, and the other an escape from the family yoke and a free-dom she had dreamed of since childhood. While they remain discreet about their short-lived affairs, any new lover who becomes at all important to them is always introduced to the other spouse. If a friendship develops between those two, nothing better; otherwise, the liaison is conducted in private and ends in its own good time without compromising the couple's relationship with each other. For the past two years Terence has had a companion, Scott, with whom he is very much in love, and for whom May has a very high regard. She explains all this straightforwardly, as if this kind of married relationship were a matter of course. And, at first a little dis-concerted, Magnus soon finds that he has a place of complete integrity within this couple at once united and independent of each other.

He returns to London and May goes with him. It is an opportunity for her to renew her acquaintance with this city and visit friends there. Most of all, she is determined to remain close to Magnus, anxious to know how things will go when he gets back to the uncle and aunt he now knows not to be his relatives, what explanations they will give, and finally what he will decide to do after this encounter. She has suggested he come and live in San Francisco, but without daring to be too insistent.

The evening of his return to the Schmalkers, Magnus questions Lothar.

'Why did you convince me I was your nephew, and so the son of those people who inflicted themselves on me? Why keep me deceived? Why lie to me all that time?'

Lothar could deny everything. He could feign incompre-

hension in the face of the accusatory questions of the young man who insists on being called Magnus from now on. He could hide behind the fact he had broken off all contact with his sister at the time the child must have been born, that he was living in exile when she adopted him, if indeed this were the case. He could pretend to know nothing, or put his accuser in the dock instead, by asking him where he gets this sudden conviction he is not the son of Thea and Clemens Dunkeltal? Who has told him this alleged secret? What proof does he have? But Lothar does not do this. He does not want to. The moment he had been expecting, but was constantly putting off as he so dreaded it, all of a sudden has arrived. The moment to admit finally to a lie perpetuated by inordinate discretion.

Yes, he knew. He had known for a long time his sister was barren, and no fertility treatment had been able to reverse this. Her younger brothers had taken the place of sons. It was after their death that the idea of adopting a child had developed, become an obsession with her. When the opportunity presented itself she seized it, for the first time ever defying her husband, who had no desire whatsoever to take in any foundling, and felt all the more reluctant to do so having just fathered a son, illegitimate admittedly but nonetheless his. To what extent Thea was aware of Clemens' infidelity, Lothar could not tell. She had always expended so much energy in denying anything that might upset her, interfere with her exalted vision of the world, she might have deliberately closed her eyes to that as well.

But the story of this adoption, explains Lothar, he only heard about later when his sister after some fifteen years' silence wrote asking him to come to Friedrichshafen. She knew she had not much longer to live, and she was concerned about her son. For despite everything, she thought of him as her son and she had loved him. But she had no one to whom she could entrust this child; her close family were dead, her friends had

gone their separate ways, and she had managed to isolate her-
self completely. Then she remembered her elder brother, the
brother she had insulted when he opposed the regime, whom
she had despised when he married a young woman of Jewish
origin, then regarded as a traitor when he emigrated to an
enemy country. But it was not only because she had no one
else to turn to that she appealed to him, but because she had
no doubt he would respond to her appeal. That he would
respond immediately, and would undertake without fail the
mission she wanted him to accomplish. Her animosity towards
Lothar notwithstanding, her trust in him remained intact, and
as death neared, it came to the fore again. Whether or not the
child should be told the truth, she left it up to Lothar to
decide. Even this lie, which after all she had meticulously and
doggedly constructed, a lie she had jealously protected, was
something she no longer cared about. She no longer cared
about anything, had lost the will to fight, the desire to live, the
strength to love or hate. She had no expectations, of either
forgiveness or pity from anyone, no hopes whatsoever, she
believed in nothing. She had plumbed the depths of despair
and was preparing to die in a state of total indifference towards
herself. Passing into nothingness, that was all. Only the future
of this adoptive son, of whose origins she knew nothing except
that he had survived the bombing of a city, still mattered to
her, and only the brother she had violently rejected seemed
worthy of trust. Thea had lived her life from beginning to
end ruled by a mixture of paradoxes and convictions as
unshakeable as they were arbitrary, without ever questioning
her position.

So Lothar was free to tell the child the truth, yet he had not
done so, having never considered the time was right. And not
a word of this truth – in any case an incomplete truth since no
one knew the child's real identity – had he breathed to any-
body, not even his wife Hannelore or his daughters, for fear of

adding to the deceit by sharing it with others without the knowledge of the person concerned. And indeed, he asks the young man how he discovered this secret. Who could possibly have told him? What happened in Mexico? But Magnus is unable to offer any explanation. How can he say, without being taken for a lunatic, 'It was the earth that told me. The earth, the insects, the sun'? He says simply, 'I just know, that's all.'

And indeed that is all he knows. The disclosure imparted to him remains incomplete, only the lie about his childhood illness and his falsified parentage has been brought out into the open and confirmed, but he is still in the dark, even more than before, about who he is and where he comes from. He retrieves from the cupboard the teddy bear he had wrapped up and put away. He unwraps it and places it on his lap. He notices the handkerchief he had tied over the diamond eyes is wet through. He unties the handkerchief and discovers the diamonds have lost all their brilliance; they are covered with a rough greyish frosting. This frosting is seeping dampness, like a patch of saltpetre that forms on the wall of a cave. He pulls off the eyes clouded with this film of grey tears, stuffs them into his pocket, and replaces them with the little buttercups that he sews back on. The teddy bear is restored to the way it used to look, with its expression of mild bewilderment. But it has no new revelation to offer the person it once protected and for so long accompanied, still providing only the name it wore tied round its neck, the cotton-thread letters now bleached of colour through exposure to the acidity of the diamond tears.

Magnus is twenty years old (but when exactly was he born, and where?) and a quarter of his life is lost in oblivion, all the rest tainted by a long-lasting fraud.

He is twenty years old, and he is a stranger to himself, an anonymous young man overburdened with memory, lacking however in the essential: his ancestry. A young man crazed with memory and forgetting, who juggles with his

uncertainties in various languages, none of which, perhaps, is his mother tongue.

He informs Lothar and Hannelore of his decision to leave England and to go and live in the United States. On the eve of his departure he walks along the banks of the Thames and throws the unseeing diamonds into the water. The hand-kerchief he has washed. It is now no more than a square of cotton thinner than a sheet of paper, translucid, of a yellowed white. He has tied it round the bear's neck again.

Echo

My mother . . . my mother's dead . . . her voice . . . so weak . . .
had to travel a great distance . . . distance . . . distance . . .
 Now I understand . . . And when . . .? when . . .? when . . .?
did that happen, that she died . . .? she died . . .? she died . . .?

Fragment 14

Here begins the story of Magnus. Here, somewhere between San Francisco, New York, Montreal, Los Angeles, and Vancouver, and many other cities besides. May Gleanerstones is a dedicated theatre-goer. She works as a drama critic for several magazines and newspapers, and is always ready to travel thousands of kilometres to seek out new works. Magnus often accompanies her on these trips. Terence is an art dealer and also travels frequently.

Together with Scott, they form a family of four, bound by unconventional ties that interweave without tangling, in which love is declined in the mood of desire and friendship.

Magnus soon adapts to this new way of life of being continually on the move. May is the figurehead of a free ship that sets sail whenever the fancy takes it and adapts easily to prevailing conditions. Thanks to her he finally shrugs off his ghosts, leaves his past behind. The horizon now opens before him, no longer gaping behind him like a black hole. But as much averse as May is to being in any way dependent, especially financially, he takes up translation, translating articles for art magazines, technical publications, essays. His work is irregular, but it suits him because it allows him great freedom of movement.

On three occasions, however, those ghosts reintrude on his life: the first time shortly after moving to San Francisco, at dinner in a restaurant one evening with the Gleanerstones and Scott, when Terence suddenly interrupts the conversation and says to May and Magnus in a low voice, 'Listen to the people at the table behind us. Listen carefully . . .' They pay attention, Scott too. The guests at the table behind them are speaking in a harsh-sounding language. Magnus shrugs his shoulders

slightly as a sign of incomprehension. May frowns, concentrating hard. 'It reminds me of something, but what?'

Terence helps her out by suggesting, 'Comala?'

May immediately concurs. 'Comala! You're right!'

Then, turning to Magnus, she says, 'It sounds like the language you spoke at times in your delirium at the hospital in Veracruz . . . those words that weren't German, that no one could identify . . .'

Magnus has no recollection of these words he apparently uttered, only the vision of that fateful night in Hamburg has engraved itself on his memory – an explosive image that has cast a new light on his life, but also a blinding image, an obstacle blocking off all his most distant past.

Scott, who feels left out of this memory game, finds a way of joining in: he gets up and goes and asks the tourists what country they are from. He returns to the table, sits downs, and turns it into a guessing game. None of the guesses his friends make is correct, so he finally tells them the answer: 'Iceland. Magnus must be a clandestine Icelander!' he announces, and proud of the word he has just elicited from the Icelanders, he raises his glass to Magnus, addressing him with a deep-toned '*Skal*!'

But to the surprise of the Gleanerstones and of Scott, Magnus displays no emotion or curiosity in the face of this revelation he regards as fanciful, and he is eager to change the topic of conversation. For the time being he has no desire to look back, to start rummaging through the rubble once more, to wear himself out ferreting around in obscure labyrinths. He is happy where he is and now wants to live only in the present.

On the subsequent occasions, his ghosts return by less fortuitous routes, evoked by current events: these occur in quick succession, in 1961 with the opening in Jerusalem of the trial of Lieutenant-Colonel Eichmann, which gets extensive

world-wide coverage, then with the construction of the wall dividing Berlin in two.

A report on the trial of the Nazi criminal, written by the philosopher Hannah Arendt for the *New Yorker* weekly magazine, causes a sensation. She is criticized for her tone, felt to be casual, arrogant, and above all for her analysis and judgment. Magnus reads the indicted report and far from taking exception to it embraces the idea of the 'banality of evil'. For him, it is no ill-considered concept but rather a finger placed unerringly on a wound so ugly and shameful everyone would rather not see it. Reading Hannah Arendt's text, he cannot help hearing in the background the voices of those other perpetrators of death and destruction he knew, with whom he came into close contact: the resounding laughter of the humorist Julius Schlack, the perfect elocution of that fine connoisseur of poetry Horst Witzel, and the deep baritone of Clemens Dunkeltal. Voices that would surely have responded, like Eichmann, in a curt monotone devoid of any remorse, 'Not guilty' to each charge made against them by a tribunal, had they been captured and brought to trial.

As for Berlin, he tries to recall the memories he has of the rare visits he made to that city when he was about seven, and he can only recollect a visit to the zoo, where Clemens took him one day. It was so unusual for his so-called father to spend time with him, that day left a deep impression on him, especially as his joy at finding himself alone at last with his 'master of the night' was immediately trampled over. At the foot of a huge statue of an iguanadon standing near the entrance to the zoo there was a young woman waiting, with a little boy of about three at her side. This visitor and his father had feigned surprise on seeing each other, as if their meeting was entirely due to chance. And this chance encounter so greatly pleased them they remained together for the rest of the outing. However, it was not the unwelcome presence of this talkative woman that

spoilt his childish joy, but that of the youngster, a chubby-cheeked kid named Klaus, for whom the 'master of the night' showed a lot more concern and affection than he had ever shown for his own son.

He can visualize the enormous dinosaur rearing up on its hind legs, its head turned towards the branches of the trees, and beyond the foliage a flag flying from the front of a building, displaying in a vastly larger format the same black cross with bent arms as the one that adorned Dr Dunkeltal's uniform.

He sees the odious cherub perched on his father's shoulders or seated on his lap, and he himself is ignored yet again. He sees the giraffes, bears, elephants and bisons, the trees, rocks and large aviaries. He sees the kangaroos casually lying on their sides, some propped up on their forelegs like red hairy humans resting on their elbows. He sees a black rhinoceros with tiny staring eyes, standing motionless on a rise, apparently only its ears capable of movement, and a lion ceaselessly pacing its jail. He sees sparrows everywhere, inviting themselves with grace-ful insolence into the enclosures of the captive beasts, and a little mouse that scuttled across a path, instilling panic in some elegant women passing by, including his father's friend – not at all frightened, incidentally, by the sight of wild beasts. But all these images come back to him in the blur of those tears of resentment and anger that clouded his eyes at the time.

What he sees very clearly, on the other hand, is a baby hippopotamus whose massive yawn greatly amused the woman and Clemens, and the name of that fat-faced hippo-potamus cub with the gaping mouth also comes back to him: Knautschke. He remembers because he combined the name of the brat cosseted by his father with that of the young ani-mal sprawled against the formless belly of its mother: he turned Klaus into Klautschke.

A few weeks after this visit Berlin was flattened, and nearly all the animals in the zoo were killed in the bombings. Had

Klaustchke and his mother suffered the same fate as the caged beasts?

Europe does not have a monopoly on crime and violence. There are plenty of both in the United States, they proliferate throughout the world. President Kennedy is assassinated, the war drags on in Vietnam, riots break out in the black neighbourhoods of most of the country's big cities, Martin Luther King in turn is shot dead by a fanatic. At the same time counter-currents build up, against a background of tumultuous music carrying forward a determined passion to live differently, to emerge from the ghettos, the quagmire of wars, the stifling oppression of a circumscribed and petty day-to-day existence. May throws herself into all these currents. Wherever things are stirring and a prospect of change is to be detected, wherever the pulse of the age quickens, she is there. 'I have a dream,' Martin Luther King repeated psalmodically a few years before he was killed. May picks up this interrupted dream and runs with it.

She has always tried to defy gravity and allow dreams to enter reality. This gained her at the age of fifteen the enduring resentment of her mother, Nora. Her parents had not been on good terms with each other for years, and her father, Lajos, had a relationship with another woman, Judith Evans, who was a friend of the family. Everyone knew but they all pretended not to know, for the sake of appearances. One day her father fell ill. Nora felt more satisfaction than anxiety at this sudden illness: her husband would be unable to see his mistress as long as he was confined to his bed. When his illness worsened, it would have been preferable for Lajos to go into hospital, but Nora opposed this, arguing he was better off at home with his family, and she demonstrated great devotion in looking after her 'poor husband'. A genuine but fierce devotion, for though she was very zealous in caring for him, she was even more

zealous in keeping him isolated. Even their daughter was only rarely allowed to go into the bedroom where her father was resting, and was not to be tired.

Her father was not resting, he was dying a slow death. And in his long agony he asked to see Judith. He begged. Nora gently wiped his face, gave him a drink, stroked his hand, merely repeating in a voice full of solicitude, 'Don't talk, Lajos, lie quietly, I'm taking care of you, everything's fine . . .' And when, towards the end, he breathed in a whisper Judith's name, wanting to shout it, she responded ingenuously, 'I'm here, my darling.'

Judith Evans had called round twice, with the excuse of making a friendly visit to get news of the invalid. Nora received her with implacable politeness, imposing on her the torture of being served tea, when every gesture, every look, were considered and calculated, and a conversation whose every phrase consisted of sickeningly bland stupid clichés punctuated with acerbic silences. Unaware of the seriousness of his condition, during her first visit Judith had hoped to see Lajos, that he would come down from his room. Sensing this desire in the woman she hated and finally held in her power, Nora dashed this expectation with a few words: 'It's impossible, he's asleep and doesn't want to be disturbed by anybody.' The second time, Judith dared to express her desire. 'I'd like to see him . . .' Nora slowly drank a sip of tea, daintily set down her cup. Judith's thudding, racing heartbeat could be heard in the silence of the drawing room. And with a sorrowful gracious smile the lady of the house delivered her blow: 'It's too late now. He doesn't recognize anyone. Thank you for your visit.' And she rose, adding with unfailing graciousness, 'I'll see you to the door.' Judith rose in turn, ghastly pale, her lips trembling. It was then that May, who witnessed this scene, intervened. 'Come,' she said, taking Judith Evans by the hand. And before her mother had time to react, she had rushed Judith out of the room, locking the door behind her,

led her upstairs, and taken into her father's bedroom the woman he loved.

'I have a dream.' Dreams are meant to become part of reality, forcing their way in with violence if necessary. They are meant to re-infuse it with energy, light, freshness, when it gets mired in mediocrity, ugliness and stupidity. The heartbeats of a woman stricken with the panic of love had released in May the will for total independence, as well as unfailing reserves of pluck.

Sequence

One day the South will recognize its real heroes . . .
They will be old, oppressed, battered Negro women,
symbolized in a seventy-two-year-old woman in Mont-
gomery, Alabama, who rose up with a sense of dignity
and with her people decided not to ride segregated
buses, and who responded with ungrammatical profund-
ity to one who inquired about her weariness: 'My feets
is tired, but my soul is at rest.'

Martin Luther King
Letter from Birmingham Jail, 16 April 1963

You cannot understand
you who have not listened
to the heartbeat
of a man about to die.

Charlotte Delbo, 'Useless Knowledge'

Fragment 15

It is not just History with a capital H that repeats itself, so does family history. In both cases the repetition is spiced with nuances, with slight variations, tempering the effect of a rehash.

The illness that twenty-five years earlier had carried off her father in less than a month strikes May down at the same age and progresses just as swiftly. Within a few days it drains her of strength, confines her to bed, and constricts her breathing, reducing her to complete helplessness. Magnus never leaves her bedside, Terence though nearby keeps out of the way. But when May senses the countdown to her death is no longer to be measured in days but hours, she asks Magnus to leave the room and to call Terence.

She tells Terence to close the door, then to come and lie in the bed beside her. It is in his arms, close to his body, a body she has never stripped naked, never embraced or caressed, that she wants to die. Only the tenderness and silence of the body of a man impervious to desire for her, that of her fraternal spouse, her sibling soul, can help her to resign herself, to pass on without fear or anger through death into the unknown. Close to the body of her lover this would be beyond her, she would feel too much rebellion and pain. And she wants to be capable of accepting the inevitable, to meet it in single combat. She wants to succeed in doing honour to her death.

Terence lies by her side, gently folds her in his arms. With their faces touching, their eyes are so close their lashes brush against each other's and their gaze is indivisible. They cannot see anything, all they perceive is a quivering glimmer like a little pool of sunshine at the heart of a bush. This amuses them.

May has not enough strength to laugh any more, she smiles. And their smiles also mingle, and their breath. They do not speak, having nothing more to say to each other, or too much to say, at this moment it is all one. And they feel content, curled up together like that, out of time, free of desire, in the starkness of love. Their closeness has never been so intense, immense, and luminous. They are in a state of absolute trust, total self-surrender to the other, total forgetfulness of self in wonderment. Never have they felt so much a presence to each other, a presence in the world – but only on the outer edge, no longer in the thick of it.

Terence sees the little pool of light that quivered as the tips of his eyelashes grow dim, he hears the breath that whispered in unison with his own fall silent. Yet he does not move, he simply holds May's face in his hands and remains there for a long time, a long time in the now infinite silence of love.

May has done honour to her death.

Magnus is waiting outside the bedroom, not expecting to be let back in. A great emptiness opens up inside him as the hours pass. His mind is blank, he feels nothing but a wave of peculiar coldness travelling through his body. He is neither patient nor impatient, he is simply there, like a tightrope walker pausing in the middle of his tightrope stretched above a desert. He has to remain very still to retain his equilibrium.

At last Terence emerges from the bedroom. He does not say a word, his face conveys nothing in particular. He slowly approaches Magnus and takes his face in his hands, just as he held May's face. Magnus closes his eyes, he lets May tell him of her death through this physical contact, and say goodbye to him with the lightest of touches. He feels in the palms of her messenger the warmth that has left her. He recognizes in this touch the texture of May's skin. Terence's hands are imbued with May's breath and smile. He then places the messenger's

hands over his ears, and he hears the sound of his lover's heart beating the way he used to hear it beat after making love, when he would fall asleep with his head resting on her breast or on her belly.

May is cremated and her ashes scattered in the wind, according to her wishes. For this ceremony of sowing the open sky with her remains, Terence hires a hot-air balloon to carry Magnus, Scott and a few of the couple's close friends. They all wear clothes of every shade of purple and green, May's favourite colours. Terence opens a bottle of barackpalinka, the Hungarian apricot brandy that was her favourite drink, and pours everyone a small glassful. They all drain their glasses to her memory as her ashes escape from the urn and disperse in empty space. A fleeting silver-grey cloud floats in the air that soon regains its transparency.

So this is what it comes down to: a life, a body once so intensely active, bubbling with words, laughter and cries, animated with countless projects, insatiable desires, reduced to a handful of pale ashes that dissolve in the wind.

May has chosen the wind and empty space for a tomb, and this empty space opens up around Magnus. The present is swallowed up in the abyss of a blue-white sky of a tranquillity to make you weep. Standing there in the slowly drifting gondola, Magnus has the impression of being an ungainly bird caught in the breeze, not knowing where it comes from or more importantly where it is going. She who opened up his horizons and set him back on the path leading towards the future is gone, and suddenly he feels a great coldness, a burning – the sensations are confused. A chill blaze ignites in his heart's core, pours into his limbs, flows through his spinal column, and silently explodes in his head, just as on that summer night in Hamburg, when the hour of Gomorrah struck, when the woman he believes was his mother suddenly let go of his hand

to dance with death. He has the same taste of nothingness in his mouth, he feels the formation in his flesh of the same precipitate of amazement and loneliness. He is not widowed but orphaned by the loss of his companion, his lover. Terence is the one who is widowed.

The chill blaze licks at his brain, and his thoughts become a yawning chasm. Appalled by his own question he wonders, 'Did May love me? And did I love her? Have I ever really loved anyone? Or was it all nothing but illusion?' He does not know, knows nothing any more, doubts everything, doubts himself. In the end he feels not so much orphaned by the loss of May as bereft of the new identity he had forged through being with her. Yes, just as when the hour of Gomorrah struck, he is going to have to start again from zero. But a zero charged with very intense memories this time, not gutted by oblivion.

Sequence

A star looks down at me,
And says: 'Here I and you
Stand, each in our degree:
What do you mean to do, –
Mean to do?'

I say: 'For all I know,
Wait, and let Time go by,
Till my change come.' – 'Just so,'
The star says: 'So mean I: –
So mean I.'

Thomas Hardy, 'Waiting Both'

Fragment 16

What May has never done during her lifetime, never tried to do, quite the contrary – come between Terence and the person he was in love with – she provokes by her death. Shortly after the scattering of the ashes ceremony Scott leaves Terence. All desire for his lover has suddenly slumped, turned to impotence. Terence's body seems untouchable, unapproachable even, as if May by dying in his arms had left something of her death on his skin and ingrained in the depths of his eyes the reflection of her face reeling into darkness, into silence. The smell of his body has changed, says Scott, the texture of his skin, and above all his gaze. He has an aura of intense, overpowering fustiness. The intolerable fustiness of death, which is so insidiously contagious.

Terence does not try to prevent Scott from leaving, he quietly surrenders to that very state of abandonment in which May left him. He becomes strangely indifferent, to everything, to everyone, to himself, while at the same time displaying great courtesy in his detachment, perhaps to temper its excess, not to give way to it too soon. He is as discreet in his self-effacement as he had previously been in charming people.

He eventually disappears completely, without telling anyone where his place of retreat is.

And loneliness closes in on Magnus, or rather opens up and deepens around him. She who had the gift of propelling dreams into reality and making the days magical is gone, taking with her all dreams, all desires, and the days have no sparkle or zest any more. He ceases to travel, to have any enthusiasm for going to plays, concerts, exhibitions. His interests as a translator shift, turning away from art and to history.

This is a vast area of study, but Magnus slowly comes back to the very thing he had tried to escape by leaving Europe, and soon he is wrapped up in it: the recent past, still very much alive, of Europe and its wars, the last one especially.

It is as if the old demons of his childhood and adolescence had stealthily followed him across the Atlantic and gone into hibernation during the long decade he has been living in this continent on the far side of the globe, indulging to excess a thirst for wandering, trying to anaesthetize himself with new experiences, with freedom; as if they had bided their time for the moment to awaken and surreptitiously resume their attack.

He transfers the energy he had expended in discovering museums and art galleries, theatres, cabarets, and underground art venues across America, and now devotes it to searching through archives and documents in the silence of libraries, and attempting to establish a dialogue with the many testimonies of both victims and perpetrators of the enormous barbarities of his century, in particular that which originated in the country of his early childhood. The translator becomes himself a historian, or rather an amateur detective accountable solely to his conscience, still tormented with questions.

But the detective becomes lost in the labyrinths of human madness so easily allied with wickedness, he teeters on the brink of the abyss of human folly and its capacity for confusing good and evil, evil and duty, and then carrying out the most shameful deeds with meekness and diligence, untroubled, in all good conscience.

Slowly the memory of his years in London resurface in his mind. He had set aside this painful memory all the time his relationship with May and his friendship with Terence and Scott had lasted. With the Gleanerstones he had learned to relish life, something he never experienced in the Schmalkers' austere house, where he felt like an intruder. But his relish has suddenly faded, or rather life has acquired an extremely acid

flavour, and he senses he will have to live for a long time with this sharp taste of grief that erodes all desire and turns all joy to sourness. And he also senses this bitterness will be all the more enduring because he will have to keep chewing on it in isolation and silence. This is why his thoughts revert to Lothar and Hannelore, who after all gave him the first chance of a new life after his fradulent parents came to grief, fleeing their crimes in ignominious deaths.

With the passage of time he can understand better Hannelore's distant attitude towards him, and above all he finally understands the reasons for Lothar's long-lasting lie, and appreciates how much it must have cost him to remain silent, to tell no one what he knew, about the child who had survived Gomorrah and was then seized on and manipulated by his sister. Lothar had fought his battle of conscience alone. Alone before the God who was at the centre of his life. God: like a silent abyss, though one from which a wind blew, causing flurries of words, unheard-of and inaudible, to sigh in an undertone.

With May he had never broached the question of God. On this subject there was no question in her mind, only a negation, the bald fact of Nothingness. In her eyes any religion was no more than frills and furbelows, of greater or lesser crudeness or sophistication, arranged round this vacuum to conceal the sickening enormity of it. The earth, the universe, human life were simply the results of a bizarre accident. Results as pernicious as they were glorious. And the only 'divine voice' she recognized was the muffled heartbeat of the living when it becomes fabulously resonant in the joyful hours of existence, the nocturnal hours of distress, and the sun-bright moments of sensual pleasure.

Was it in order to leave Magnus with only the memory of these sun-bright moments that she expelled him from her bedroom as death neared? Or was it because Terence's love

was more intimate, more precious to her than any other? The doubt that arose in him on that day of farewell, up there in the cold blueness of the sky, continues to nag at him. Was their relationship as strong, as free and bright as he thought? Was he able to love her well enough to meet her expectations? Was he able to love anybody in fact? And supposing that in the ravishment of his childhood, on the night of Gomorrah, he had also lost all capacity for love? Supposing he was left with only a heart half-charred in the flames that had enveloped his mother, crystallized in the salt of his amazement, tears and terror? Doubt gathers, spreads through his entire being, gnaws away at him.

But would he be so susceptible to doubt, he wonders when his perplexity reaches a peak of intensity, if a second ravishment had not taken place in the wake of the first, not violent this time but soothing, effected day after day, painstakingly, by Thea and Clemens Dunkeltal, the mad woman and the assassin? How could you not suspect everything, even yourself, when so many lies have been distilled inside you?

So his old demons beset him again. They become ever more pressing as the months go by and in the end so thoroughly regain possession of him that he decides to return to Europe after a dozen years' absence if not abjuration.

Resonances

'Magnus? Who is Magnus?' May had asked.

Magnus is an average-sized teddy bear with a very worn light-brown coat, slightly orange-coloured in places. A faint smell of scorching and of tears emanates from him.

His eyes are peculiar, of the same shape and golden yellow – slightly faded – as a buttercup, which gives him a gentle gaze, clouded with amazement.

Magnus is a man of about thirty years of age, of average build, with broad shoulders, a rough-hewn face. An impression of strength and lassitude emanates from him.

His eyes, of brown with bronze reflections sometimes turning to yellow amber, are deep-set, which gives him a peculiar gaze – that of a watchful dreamer.

> *Here I and you*
> *Stand each in our degree:*
> *What do you mean to do, –*
> *Mean to do?*

'And what's become of May? Did she stay behind in Comala?'

> *Black milk of first light . . .*
> *We dig in the air a grave . . .*

Fragment 17

'I was sure you would come back one day, and in just this way, without warning, like the prodigal son,' says Lothar. 'All these years, without any news of you at all . . . I imagined various lives you might be leading, I hoped you'd found peace. And forgiveness.' Lothar speaks in German, and this language which Magnus has not spoken for years sounds strange to his ears. The words reach him from a distance, as though fogged and frosted, embedded in a rough matrix, and suddenly he remembers the diamonds with which Thea had tricked out his teddy bear, diamonds encrusted with grey tears.

The words of the language that used to be his begin to stir at the back of his throat, quiet faltering words, but they gather in a lump. A coagulation of speech sounds whose beauty is clouded, crackled. He cannot dissolve it to free the words; his throat is sore, his mouth dry. He responds to Lothar in English, but his reply is evasive for it was not so much peace he found over there, far away from Europe, as fresh and intense joy, a joy all of a sudden reduced to dust, leaving him bereft, inwardly adrift, ringing hollow. As for forgiveness, while he can envisage perhaps one day being capable of it with regard to the damage done to his childhood by Thea's stealing and deception, he does not in the slightest extend this possibility to Clemens Dunkeltal for whose crimes there can be no excuse, no indulgence. And besides, he adds, not having been the victim of the crimes perpetrated in the camps where the exterminating doctor held sway, he has no right to forgive on behalf of those martyred.

Lothar is at home by himself. Hannelore has gone to Liverpool, where Erika and her husband live, to help her daughter who

has just given birth to her fifth child, a little boy after all this time, the first in the family, named Jonas. Else lives in London with her husband and their twin daughters, Doris and Clara. Portraits of Erika and Else taken on their wedding day hang on a dining-room wall; there is also a recent photograph of Hannelore and Lothar's six grand-daughters, ranging in age from three to about fifteen. All of them are plump, blonde and laughing, except one, Myriam, a slim dark-haired adolescent who stands stiffly, her arms held tensed on either side of her body and her fists clenched. She is Erika's oldest child, the one he knew in the cradle. She was the first new-born baby he had ever seen at close quarters, and he had been deeply disturbed by her at the time. He remembers her tiny fists already then tightly closed, her frog-like grimaces, her resemblance to a very old sage to whom he attributed a knowledge as far-reaching as it was vague, a knowledge of the mystery of life, and he remembers how in the presence of this little baby girl he dreamed of his own early childhood that was lost in oblivion.

Certainly traces of a maternal love – of smiles, melodious words, caresses and radiant looks – still lie dormant in the depths of his being, but they do not derive from Thea. And these traces buried beneath the rubble of Gomorrah torment him anew, like a name you know that stubbornly remains on the tip of your tongue when you try to recall it, a familiar tune that plays somewhere inside your head without allowing you to catch a single audible note.

Lothar mentions that Myriam is very gifted at drawing and sculpture, but that she devotes all her energy to this artistic passion to the detriment of her studies, and she is often in conflict with her parents. He shows Magnus two statuettes she has recently modelled: one of a young siren, her upper body held erect, arms raised above her head, hands buried in hair that looks like a tangle of seaweed; the other of a spindle-thin man, with a wader's beak, and bird's feet instead of human hands and feet, jumping over an invisible obstacle. Obviously,

there is a lot of talent in Myriam's fingers, and above all an accumulated strength and anger enclosed in her fists.

In the Schmalkers' house, time seems to have slipped by, slowly, delicately. The same tidiness, the same spotless cleanliness, and the same deep calm prevail – everything that Magnus, when he still lived here under the name of Adam, found oppressive and was eager to escape. Now he appreciates the quiet and peaceful atmosphere of a house of study, where life itself, events taking place in the world, newspapers and books, the thoughts and feelings of the people who live here are daily topics of reflection, of a sustained effort of comprehension.

Time has not slipped by Lothar, but steadily, in depth, penetrated his body, which beneath its slightly coarsened and wrinkled skin has lost its vigour and is becoming stooped. His hair has turned white, his voice is a little husky – it purls over a vast underlayer of silence. Time has in particular polished his eyes, which gleam with the brightness of very pale blue-grey quartz in which drops of light appear to be mounted. And when he rests his gaze on the person he is speaking to, that person is embraced within the orb of its brightness.

Lothar puts to Magnus the question he has been deferring since the start of their conversation. He asks him if he believes in God.

'I find it difficult enough to believe in myself and others.'

This oblique response is met with a smile, and Lothar says that belief in God is dependent on the same bold and often demanding act of faith as belief in man. With no certainty, no security, and no rest in this act of heart and mind that every day has to be renewed.

He sees Else again, who comes to visit her father. She is just as vivacious as when she was a young girl. While they talk in the drawing room Magnus is reminded of Peggy Bell, with whom

he fell hopelessly in love after stealing a kiss from her in this very room, and he asks after her.

'Ah, Peggy . . .' says Else, sounding suddenly upset. 'I only rarely see her now. She's so changed since Tim died . . .'

'Tim? Who's Tim?'

'Timothy, her husband. He died last year. He fell off the edge of a cliff while out walking, in Kent, where they were on holiday. Peggy wasn't with him at the time of the accident, and she didn't see him fall. She only found out what had happened several hours later, when Tim's body was found on the rocks.'

'And since then?'

'It's difficult to know what she's up to. She's unpredictable in her behaviour. She disappears for weeks on end, turns up again without warning, and when you finally manage to get in touch with her she's evasive, very uncommunicative, almost mute. And she used to be so warm and talkative! All I know is, she wants to leave England. She says she can't stand living here any more, as if Tim's ghost haunted the whole country, and only in a different place could she begin to forget. I don't really understand her any more . . .'

Speaking of the misfortune that has put Peggy to flight suddenly revives Magnus's own distress in confronting his past, and his grief over May's death, crises that also made him unsettled and elusive. And he realizes that at heart he does not want to move back to London; he has returned only temporarily, even if he does not yet know when he is going to depart again or what his destination will be. He is incapable of the quiet and settled life of someone like Lothar, but the world too can be made a house of study, however erratic and fragmentary this study might be.

Resonances

'Am I pretty?' Peggy Bell had asked.

She had the prettiness of a seventeen-year-old, with a dimple in her left cheek, a freckled complexion and the merest hint of a cast in her lime-green eyes that gave her a sometimes dreamy, sometimes mutinous look.

And red-gold hair.

She had the innocence and anxieties of a seventeen-year-old, a mixture of ingenuousness and guile, and a mad impatience to be independent.

A taste of fruit on her lips, and hair the colour of oranges.

'Am I pretty?'

One boy kissed her, another married her.

You hear . . . laughter. Time-worn laughter, as though weary of laughing . . .

One boy married her – did he die of that love?

'Peggy, pretty Peggy Bell, what's become of her? Did she remain in Comala?'

> *Black milk of first light . . .*
> *We dig in the air a grave . . .*

Fragment 18

Magnus leads the same kind of existence in London as he did in San Francisco after May's death. He frequents libraries and works on translations. He also give private lessons in Spanish. The Schmalkers offered to put him up – Hannelore displays much more warmth towards him than in the past when she thought he was the Dunkeltal's son – but he prefers to visit them often rather than stay with them. He has rented a studio in an area to the north of the city.

There is no house he has ever become attached to, that he might regard as home. He has always left the places where he lived in a hurry. He feels no nostalgia even for the house on the moor where as a small boy he thought he was happy, and from which he had to flee in panic. Especially not for that one, standing there like a mirage of peace and affection on the brink of one of the mouths of hell. The memory of the wretched lodgings where he subsequently lived in Friedrich-shafen inspire him with less disgust, for at least that place had not been an unspeakable sham. It was in keeping with the ambient squalor, whose extent became every day more apparent. Vainglorious Thea had slowly shrivelled there, then burnt out like an acrid fire. The Schmalkers' house was a kind of safety chamber between two contrasting environments, two countries, two worlds, a rather uncomfortable and gloomy halfway house but turning out to be very secure as he approached adulthood. With May he led such a nomadic existence that in essence she was his only landmark and place of anchorage. May, his ever-drifting mistress-island.

But what lies beyond all these places of transit? What comes before the cellar in Hamburg, the night of Gomorrah?

Sometimes he thinks he has a fleeting memory of a room bathed in milky light. He sees this light spilling over the pale wooden blocks of a parquet floor, shimmering on the walls, and an impression of delightful tranquillity emanates from this image as subdued in colour as a faded print, illuminated with emptiness and silence; a very uncluttered image that quivers slightly in its fixity.

It is a long time since flash floods of crude blinding colour entered under his eyelids, sending stridencies no less disturbing than voluptuous coursing through his body. Now, only this opal-hued vision steals unexpectedly into his eyes, leaving in its wake a poignant sense of peace – a peace beyond compare, enjoyed by his entire being in days long gone by, days still not resigned to their passing.

Some mornings, when first light filters through the window blind in his bedroom, he experiences the fleeting and benevolent caress of this sense of peace, and feels on his eyelids the luminous shadow of a face bent towards his own, a breath that gaily sings words in an undertone. A dawn mirage, a mirage of drowsiness, which dissipates as soon as Magnus wakens and regains consciousness. Then he recalls that evening at the restaurant in San Francisco, when Terence and May thought they recognized the language in which he had uttered a few phrases in his delirium at the hospital in Veracruz. But weary of investigating his lost past, wanting to put behind him his harrowing amnesia, he had refused to follow up this lead. May's death brought with it the collapse of the defences he had erected against the haunting lacunae in his powers of recollection, and once again from his desolate memory rises an urgent call, like a siren song. It is possible, he now says to himself, that these ripples of silky light stealing over his skin as he emerges from sleep derive from reverberations of his childhood – his childhood somewhere in Iceland. However, while he does finally entertain this possibility, he leaves it in abeyance, fearful

of destroying the sweetness of his dream by launching himself into an investigation he would not even know how to conduct.

He contents himself with questioning the bear with the buttercup eyes that patiently keeps vigil on a shelf in the darkness of his wardrobe: a silent questioning, suited to the teddy bear with the slightly squashed nose and crinkled ears.

Magnus talks to Magnus, wordlessly, soundlessly, senselessly.

It is only several months after his return to London that he sees Peggy Bell again. She has finally found a way to put some distance on a long-term basis between herself and her homeland, where she continues to feel trapped in the widowhood that came on her too suddenly, too devastatingly: by accepting a job as an English teacher at a school in Vienna. And before moving to Austria she wants to learn a little German. Else has suggested she get in touch with Magnus. This proposal takes him by surprise and above all raises misgivings, for he has never taught his mother tongue, which in any case he still suspects might not actually be his first language, and which he only uses with the Schmalkers, Lothar preferring to talk with him in German. But his relationship with the language remains so ambiguous that an equally tortuous idea occurs to him: he tells himself that by teaching it to someone else, who herself is anxious to evade a too painful memory, he will succeed in smashing the matrix of gloom and chilliness rigidifying the words, and give them a new sound.

They are both on time to meet as arranged in a café, and are waiting, seated at different tables. Neither has recognized the other. They eventually identify each other by the way they both keep looking towards the door every time it opens to admit a new customer – they are the only ones to behave in this way. First taking surreptitious glances, they then observe each other more carefully. The young woman he has noticed finally gets up and makes her way towards him. She is wearing

a grey gabardine, belted at the waist, and a dark lilac-coloured felt cloche hat.

He smiles, and inviting her to sit at his table says, 'Peggy Bell?'

She immediately corrects him, comprehensively sweeping aside both her nickname and her maiden name to avert all familiarity: 'Magaret MacLane. So you must be Adam Schmalker?'

But he too has changed his name and in turn corrects her. 'Magnus.'

'Ah, yes,' she says. 'Else told me . . .'

She does not complete the sentence. Magnus soon discovers she has a habit of suddenly falling silent in the middle of a sentence, leaving her words suspended.

She smokes a lot, stubbing out each cigarette after a few puffs. She smokes in the same way she speaks, in fits and starts, nervously, suddenly breaking off as if changing her mind. The flighty young girl Magnus knew of old would switch without transition from laughter to slight melancholy. Now she switches from a staccato delivery of words to abrupt silence. Her lime-green eyes have acquired a cold glitter, with no gaiety or reverie to lend them any golden reflections, and she so rarely smiles that the dimple in her left cheek remains almost imperceptible. Even her freckles have faded, and her girlish hands have lost their fleshiness, and are now thin and fragile. Finally, when she removes her hat, Magnus recognizes her lovely tawny-coloured hair, but cut short. And is she examining him just as closely, he wonders, comparing his present appearance with that of the adolescent she had fun one day in seducing? But does she even remember him? Has she ever attributed the least importance to him?

Their first encounter does not last long. It is a meeting without warmth, pretty heavy-going in fact, so tense and aggressive is Peggy in asserting her identity as Margaret MacLane. She has come only to discuss terms and arrangements for the

lessons she wants to take. Any other topic of conversation is brushed aside. She asks Magnus no personal questions and is no more prepared to allow him to question her about her own past or about her present life and what her plans are. At the end of this strictly professional interview, it is decided that she will come to her teacher twice a week for two one-and-a-half hour lessons, and that she will pay him at the end of each lesson. With a decisive gesture she puts her cloche hat on again, gets to her feet, says goodbye, and quickly walks away without a backward glance.

Sequence

Loneliness whose big heart is clogged with ice
How could you lend me the warmth
You lack and we feel embarrassed
And scared to regret?

Go away, we couldn't do anything for each other,
At most exchange our ice
And for a moment watch it melt
Under the dark heat that burns our brow.

Jules Supervielle, 'Sun', *The Innocent Convict*

Fragment 19

His student is not particularly gifted for languages, but so eager is she to learn, determined even in her impatience, that she makes fairly rapid progress. As soon as she feels well enough equipped to express herself in German, she uses only that language to communicate with her teacher. And gradually her behaviour relaxes. She becomes less defensive, no longer talks in curt snatches. Finally, she agrees to resume her old nickname, Peggy, as if this linguistic migration made her feel young again, liberated her.

Magnus notices this gradual transformation, and at first his explanation for it is the effort Peggy has to make to construct her sentences correctly, this concentration monopolizing her attention and thereby distracting her from the pathological guardedness she otherwise imposes on herself when speaking to anybody. But he soon suspects some other reason remains hidden behind this rather simplistic analysis, a more complex, obscure reason, related to the tragedy in Peggy's life, as if Tim's death had cast a pall over the mother tongue they had in common, the intimate and everyday language of their relationship as a couple, of their love; as if it had blighted that language. In fact she never speaks of this tragedy, and has never mentioned her husband's name or made the slightest reference to him. Her assiduousness in shrouding in total silence everything about her life with Timothy MacLane makes this silence weirdly penetrating and disturbing. Magnus detects in it the constant cry of inconsolable love.

The lessons turn into increasingly natural and spontaneous conversations that sometimes extend well beyond the time they are supposed to end. They eventually abandon the ritual

of the lesson in Magnus's studio flat, and as soon as the weather is fine they go out for a walk, in town or in the parks, or meet in a museum or café, depending on what they feel like doing that day. But she never suggests meeting at her place.

However, one morning she telephones Magnus to invite him to come to dinner that evening. When she gives him her address, which he did not know, he realizes that she lives close to where he is, although she had led him to believe she lived in another part of town.

A pretty white two-storey house, with tubs of flowers on the door step, and the front door painted dark green. There is no name on the bell, the little nameplate has been removed, which makes Magnus feel suddenly hesitant. He pushes the bell any-way, but it produces no sound. After a few fruitless tries, he knocks on the door. His knocks resonate strangely as if fading away into empty space. Yet the door opens and Peggy, in a pale yellow dress sprinkled with tiny flowers and orange-coloured butterflies, stands in the doorway, smiling.

The house is actually empty, and naked light-bulbs hang from the ceiling. Peggy remarks casually that she has sold her house, the removers have been that very morning, and she is leaving the next day for Vienna. Magnus alternates between amazement and anger at Peggy's mania for not saying any-thing and then suddenly presenting a *fait accompli* reaches an infuriating level, but he betrays neither his surprise nor his annoyance. After all, he says to himself, it is better like this: that she should go, that this secretive woman with her bizarre quirks should disappear as suddenly as she had turned up again. Yes, that she should disappear from his life before he became too fond of her presence, before he allowed himself to fall into the trap of disappointed love. He observes her with forced coldness. Certainly, she looks pretty in her floaty dress the colour of a starry dawn, with a halo of red curls round her forehead, her bright green eyes and child-like smile, but he keeps these charms at a distance, as if admiring

a lovely statue behind a glass case in a museum, on his way past it.

In the unfurnished living room she has improvised a table by placing a plank of wood on some trestles and set two garden chairs facing each other. She has covered the plank not with a paper tablecloth but a large magnificently woven damask cloth in silky shades of white and yellow. The plates are paper plates, but the glasses are crystal. She has bought some excellent wines, and offers him black olives and cashew nuts served in plastic containers while they await the delivery of a take-away meal ordered from an Indian restaurant. He has never seen her so relaxed and gaily talkative, except in the old days at the Schmalkers' house, and it is as though time has shifted, as if the clock has turned back, and he has before him the delightful flighty young girl from whom he stole a kiss. But this evening he has no desire to kiss her, but rather to slap her. And besides, this fraudulent young girl is absurdly chattering on in German, and this irritates him. Everything irritates him, himself first and foremost for taking part in this farce he is at a loss to understand and in which ultimately he is not in the least bit interested.

The meal is delivered and Peggy hastens to serve the dishes while the food is still hot. Magnus eats without appetite and drinks without pleasure, though the wines are superb. He grows increasingly bad-tempered as his hostess, animated by the wine that she takes with little sips of enjoyment, becomes more and more radiant. And suddenly unable to contain his annoyance, he says in English, 'I'm bored.'

Then driven by a cold rage whose intensity he would be unable to explain, he goes on, still speaking in English: 'Yes, I'm bored with you. I'm disappointed in you. I taught you my language, even though I'm averse to speaking it, but what have you taught me? Nothing. For nearly five months we've seen each other twice a week, sometimes more, but never have you

111

told me anything about yourself, or been bothered about me. Just who are you bothered about? No one but yourself. We were neighbours, so why pretend you were living on the other side of town? It's a small detail, but why always be evasive and misleading, conceal things, lie? For you lie, you like to lie, to invent secrets, to fabricate a bogus mysteriousness. It's childish and tedious.'

Peggy listens. She is no longer smiling. Her face has lost the flush and radiance the wine had given it. Even her lips are white.

He sees her sitting there in front of him, very stiff, as though nailed to her chair, with a chalky complexion, her hands clenched on the tablecloth. Far from being moved by the violent distress he has produced in her, he continues his indictment.

'And let me tell you, you're not honouring the memory of your husband by refusing to mention him, never uttering his name, not even here, this evening, in this house that was also his, where you lived together, and which you've just sold off like some unwanted piece of old furniture.'

He hears the quickened breathing of the young woman, paler than her dress the colour of a sad dawn that hangs loose on her paralysed body, and he hears his own voice whose inflections and quality are bizarrely unrecognizable to him, and he does not know where the harsh words he utters in this aggressive tone come from. 'I don't love you. I've never loved you, and I never will . . .' With calm cruelty a voice that is not his own delivers words full of hostility, bitterness. Words that are no longer his, have nothing to do with him, appal him. But they issue from him, like the moans or confused words that issue from a sleeping man. 'There's nothing about you that I love, neither your voice, your body, your skin, nor your smell. Everything about you is repellant to me . . .'

Then a curious transfer or, rather, displacement occurs:

Peggy slowly gets to her feet and takes over the acrimonious monologue in a subdued whispering voice: 'Everything about you is repellant and unbearable to me. I wish you'd disappear. But even that wouldn't be enough. I wish I'd never met you. Never.'

With these words she falls silent, standing behind her chair, her hands resting on the back of it. She stands there very erect, with a fixed stony gaze, lost in a vision that envelops her in a bluish light – the scene brought to life by the declaration of non-love their two crazed voices delivered a moment ago is suffused with the same light as on the day it actually took place, out on the cliff-tops.

On the towering chalk cliffs overlooking the English Channel, white rock and grey waters with reflections of steel blue, purple and silvery green, up there, where the view is so extensive, where you can breath a sense of unlimited space. Some evenings, when the weather is clear, you can see France on the other side of the Channel. Up there, where the wind blows free, carrying sea, sky and forest smells, gulls nest on the crags, black-headed sheep graze level with the sky.

Up there, a couple went walking one spring morning. It is this couple that Peggy can see, that she watches, unblinking, so intensely that Magnus too can see the scene in that steady gaze.

And the past invites itself into the dining room, and takes its place at the table between the two who are dining together.

Two figures walk with slow measured steps. They seem to glide through the grass rippling in the wind. Sometimes one of them stops, and the other turns to face the one who has stopped, then the couple resume their progress.

A man and a woman, they walk side by side but do not take each other's arm or hold hands. They brush shoulders, and yet there is a sense of insuperable distance between them.

Their mere presence on the cliff-top is enough to harden the morning light, erode the peacefulness of the place, circumscribe the immensity of space and reduce it to a stage set.

They have reached the edge of the cliff. They face each other, less than a metre apart. The sun is still weak, the sky a milky blue, the sea a pinkish grey, darkening on the horizon. The woman speaks without raising her voice, but the wind that steals everything – pollen, dust, sand and leaves, smells and sounds – snatches her words and carries them off in its invisible folds to sow them in another place, at another time.

Standing there stiffly, with her hands stuffed into the pockets of her raincoat, the woman says, 'I'm bored with you, bored to death. I don't love you. I've never loved you and never will. There is nothing about you that I love, neither your voice, your body, your skin, nor your smell. Everything about you is repellant and unbearable to me. I wish you'd disappear. But even that wouldn't be enough. I wish I'd never met you. Never.'

The man says nothing. He is dazed by these words that require no answer, that nullify anything he might say. He recoils a few steps under this verbal assault.

He is standing on the very edge of the cliff, and the void to which he has his back turned stealthily wraps itself round his heels, creeps up his legs, swirls in his knees and surges up to the back of his neck in an icy rush. He has no need to see the void, his whole body can sense it, as it would sense the presence of a wild animal crouched at his heels. He is seized with terror and cannot move. He casts an imploring glance at the woman, not for her to say some tender words at last – he is at that moment well beyond, or well short of, any hope of love. He is incapable of any sentiment, utterly overcome with vertigo, with pure, thoroughly physical panic. All he expects is a gesture, an extended hand to wrest him from the pull of the void. But the woman remains impassive, with her hands in her

pockets, and the look she darts at him has the brutality of a slap in the face. Nevertheless he clings to that look, spiteful as it is, it is his only lifeline, helping him to keep his precarious balance.

Has she understood his plea? She turns her head away, lets her gaze wander elsewhere, indifferent. Oh, look, the sea over there has turned a shade of turquoise, and there's a seagull flying beneath the clouds, screaming its hunger, and there's a ferry sailing by, a fast-moving little black speck, like a scuttling beetle. She smiles and her smile is carried away by the wind.

She hears a slight sound. She turns round. There is no one there. The man has disappeared. That's what she wanted, isn't it? A few seconds go by, longer than a lifetime, and another sound can be heard, a distant thud, ghastly in its brevity and flatness.

She walks off, quickening her step so much she is almost running. She is not thinking at all, she refuses to think. She is a rolling stone, and there was another stone that fell, that dropped into the water with a horrible dull sound. Why would she be thinking, or how? She has just shed her humanity.

Sequence

A heath.

KENT: Who's there, besides foul weather?

GENTLEMAN: One minded like the weather, most unquietly.

KENT: I know you. Where's the king?

GENTLEMAN: Contending with the fretful elements;
Bids the wind blow the earth into the sea,
Or swell the curled waters 'bove the main,
That things might change or cease . . .

LEAR: My wits begin to turn.
Come on, my boy. How dost, my boy? Art cold?
I am cold myself . . .

FOOL: He that has and a little tiny wit
With heigh-ho, the wind and the rain –
Must make content with his fortunes fit,
Though the rain it raineth every day.

William Shakespeare
King Lear, Act III, scenes (ii) and (iii)

Fragment 20

Magnus has told no one of what happened at Peggy's, and before that on the cliffs of Dover. To Peggy herself he said nothing at the end of that dinner to which Timothy invited himself, like some freakish prompter hidden in his prompt-box supplying the text of a completely different play from the one being staged. When she had finished her impromptu reenactment of the scene forced on her, Peggy sat down and slowly drained her glass. Her features were drawn, there were yellow-tinged rings round her eyes. Then she rose again and began to clear the table. She went to fetch a large plastic bin bag from the kitchen, and threw into it the remains of the meal, the paper plates and crystal glasses. She bundled up the damask cloth and stuffed that into the rubbish bin as well. She seemed to have forgotten her guest, carrying on with tidying the dining room as if she were alone. Magnus dismantled the trestle table and returned the two chairs to the small garden on the other side of the bay window. A very fine rain fell silently, barely wetting the leaves of the bushes. From one of the neighbouring gardens came the plaintive and monotonous hooting of an owl.

When everything was in order, Peggy lit a cigarette which she smoked pacing the empty room. She continued to ignore Magnus's presence. Then he asked her where she planned to sleep; she couldn't spend the night in that empty house. She shrugged her shoulders by way of response. As he persisted in staying on she said, 'Go away now. I don't need you. I'm leaving tomorrow morning. Everything's ready.' He left but remained for a long time standing in the street, opposite her house. He saw her come out, put the rubbish bin on the door-step, lock the door, then walk away. He followed her without

her noticing. She walked to a main road, where she hailed a taxi. And she disappeared.

He returned to the house, opened the bin and removed the damask tablecloth stained with wine and sauce. He folded it up and took it away, along with one of the two glasses, the one that was just barely chipped, the other having shattered.

She has been gone five months now. She sent Magnus a postcard with seasonal greetings at the end of the year but giving no details at all of her life in Vienna. Else does not hear much more from her.

The Schmalkers' house has a new resident, Myriam. She has come to live with her grandparents so she can attend a course at an art school in London, and more importantly to escape the family home where she refuses to take on the role of big sister responsible for helping mother with the younger ones. She gets on better with Hannelore and Lothar than with her parents. They treat her like an only daughter and not as the eldest of a large family. She has moved into the bedroom that used to be Magnus's, and has fixed up a studio in the basement.

Myriam does not talk much, especially in the presence of strangers. At her first meeting with Magnus she says very little, but she scrutinizes him with an intense gaze. The gaze of a small wild animal, direct and fierce, and at the same time that of some startled creature, keyed with mistrust. Hannelore says of her granddaughter that she is like a ray of sunshine in their house, but a capricious sun that sometimes throws pellets of cold, dark light when her work does not meet with her satisfaction, when it falls short of what she wanted to achieve; then she destroys the work judged to be too feeble, unworthy of the dream that inspired it.

The light of day, meanwhile, is slowly fading from Lothar's eyes. For some time he has been suffering spells of dizziness,

deteriorating eyesight, easily induced breathlessness in his voice. Magnus offers to read to him when he visits. 'Now,' says Lothar, 'I can't engage with the author of a book by myself, I always need a reader, so there are three of us. The vocal inflections of the intermediary between the author and me reverberate on the text, and then I hear nuances I might not have discerned reading alone in silence. This sometimes produces unusual surprises . . .'

In order to be surprised better still, he sometimes asks each of his intermediaries to read him the same pages of a book – pages he ends up knowing by heart but in a polyphonic way, and this knowing 'by heart' thereby becomes tremulous, swells and fills with unexpected echoes, questions, murmurs. He applies this procedure to biblical texts as well as literary texts, to poems and daily newspaper articles, and depending on whether the voice is that of Hannelore, Myriam, Magnus, or some other person, the words resonate differently. Hannelore's voice almost imperceptibly slows and softens when a passage stirs doubts and anxieties in her. That of Myriam suddenly hammers out abruptly the words of sentences that evidently annoy her, against which she rebels. Magnus's voice punctuates with infinitesimal pauses the sentences that disturb him, or whose meaning thwarts him, as if he were trying to tame them.

For a while Lothar keeps coming back to the Sermon on the Mount, as recorded in St Matthew's gospel, and to the many commentaries on it, including that of Dietrich Bonhoeffer in his book *The Cost of Discipleship*, published in Germany shortly before the Schmalkers were forced into exile and ended up in London. When Magnus reads out pages written by this author he knows Lothar is listening not merely to a text but to the words of a man he knew, respected and admired, a living being who paid with his life the non-negotiable price of 'costly grace'. In his prime, at the peak of his intellectual powers, in the full vigour of love, he paid the uncompromising price of

that grace with his life, on the end of a rope, on a gallows erected at dawn in a concentration camp, by order of the Führer holed up in the bunker where he was to kill himself three weeks later. Magnus imposes a neutral tone on his voice, effacing himself before the voice of the deceased writer, allowing Lothar to engage in a dialogue with his friend and master. And while concentrating on his reading, Magnus listens to the old man's breathing, whose sound gradually alters in the course of listening, is punctuated with discreet sighs, revealing not so much an emotion, agreement or disagreement, as a mind keeping pace with that of the other, from time to time halting on the fringe of a word, an idea, a desire, an illumination. Or a dizzying insight, such as Bonhoeffer's comment echoing the call not to set oneself up as judge: 'If, in judging, what truly mattered to me were the destruction of evil, I would seek evil where it truly threatens me: within myself.'

Timeline

- Born 4/2/1906 in Breslau. Sixth child (one of eight siblings) of Karl Bonhoeffer, professor of psychiatry and neurology, and of Paula, née von Hase.
- 1923–27: theological studies at Tubingen, then in Berlin.
- 1927: presents his doctoral thesis in Berlin, entitled *Sanctorum Communio: A dogmatic investigation into the sociology of the Church*.
- 1928–29: curate in Barcelona of the German-speaking Protestant community.
- 1930: presents his *Habilitationsschrift*, allowing him to become a university teacher, entitled *Act and Being*.
- September 1930–June 1931: scholarship for post-graduate study in the United States (at Union Theological Seminary in New York).
- 1931: chaplain to the students at the Technical School of Charlottenburg. In September, takes part in the ecumenical conference in Cambridge (elected youth secretary of the World Alliance for Promoting Friendship through the Churches). On 15 November is ordained at St Matthaus church in Berlin.
- 1933: Hitler comes to power. D. Bonhoeffer immediately recognizes the fundamental evil of this Führer that Germany welcomes as a saviour, and publicly warns of the danger that 'the image of the leader might slip into the image of the misleader . . . The leader and his office will be deified in a caricature of God'. He also condemns racial hatred and persecution of the Jews, extended to Christians of Jewish ancestry. 'The exclusion of Jewish Christians from

121

the community destroys the substance of Christ's Church
. . . The Church is not the community of those who are
kindred, but the community of strangers who have been
called by the Word. The people of God is a order that super-
sedes all others . . . "The Aryan Paragraph" [proclaimed
7 April 1933] is a heresy and destroys the substance of the
Church.' (Tract written in August 1933)

- October 1933–April 1935: serves as minister to a parish in
London.
- 1935–37: runs one of the pastoral seminaries set up by the
Confessing Church (separated from the German Church,
which is completely compromised by its collaboration
with the Nazi regime) at Zingst, then at Finkenwalde
in Pomerania. Authorization to teach in university is
withdrawn from him in 1936.
- 1937: publication of his work *Nachfolge* (*The Cost of Disciple-
ship*). In October the Gestapo close down the pastoral sem-
inaries; arrest of several former seminarists at Finkenwalde.
- 1938: first contacts with the Abwehr resistance circle that
forms round Ludwig Beck, which is joined by Hans Oster,
Wilhelm Canaris, Karl Sack . . . His brother Klaus Bonho-
effer, his brothers-in-law Rüdiger Schleicher and Hans
von Dohnanyi also join the German resistance. 'There is a
satanic truth. Its nature consists in denying, under the guise
of truth, everything that is real. It lives on hatred of reality
and of the world created and loved by God. If we call one
who is obliged by war to deceive a liar, the lie acquires a
moral sanction and justification totally contradictory to its
nature.'
- 1939: publication of the book inspired by his experience
in the seminary at Finkenwalde – *Life Together*. Travels to
London, then to the United States, but cuts short his stay
and returns to Germany on the last ship to make the
crossing, just before the declaration of war.
- 1940: banned from expressing himself in public and obliged

to inform the police of all his movements. He works on his magnum opus *Ethics*, not to be published until after his death, by his friend Eberhard Bethge. Plays an active role in the political resistance movement.

- 1941–42: banned from publishing. As part of his resistance activities he makes several trips to Switzerland, Norway, and Sweden (within the context of ecumenical relations). In November 1942 he becomes engaged to be married to Maria von Wedemeyer.
- 1943–45: on 5 April 1943 is arrested by the Gestapo, along with his sister Christine and brother-in-law Hans von Dohnanyi, and incarcerated at Tegel military prison. Until August 1944 he continues to read, study, write – letters, notes, outlines for projects . . . 'Now I pray simply for freedom. There is moreover a false resignation, which is not at all Christian. We need not as Christians be ashamed of some impatience, yearning, opposition to what goes against nature, and of a strong craving for freedom and earthly happiness and the power to act.' (Letter from prison, 18 November 1943)
- After the failure of the Von Stauffenberg plot against Hitler on 20 July 1944, the Gestapo find documents proving his involvement in the conspiracy. His brother Klaus and his brother-in-law Rüdiger Schleicher are also arrested. On 8 October 1944 he is transferred to the Gestapo's underground prison on Prinz-Albrechtstrasse in Berlin. On 7 February 1945 he is sent to Buchenwald concentration camp, then to Regensburg, and finally to Flossenburg
- 9 April 1945: he is executed along with General Hans Oster, Admiral Wilhelm Canaris, lawyer Theodor Strünk, Judge Karl Sack and Captain Ludwig Gehre. Hans von Dohnanyi is killed at Sachsenhausen; Klaus Bonhoeffer, Rüdiger Schleicher and another accomplice, F.J. Perels, in Berlin.

'The idea of death has become increasingly familiar to us in

recent years . . . It would not be true to say we wish to die –
although there is no one who has not experienced a certain
weariness, to which on no account must we give way – we are
too curious to give up or, to put it more seriously, we would
like to have longer to see what meaning our broken life has.
Nor do we sublimate death, life being too important and
precious to us . . . We still love life, but I believe that death can
no longer surprise us very much. After the experiences of war,
we hardly dare confess our desire that it should not strike us
down casually, suddenly, on the periphery of reality, but in the
fullness of life and in the thick of the action. It is not outward
circumstances but we ourselves who will make our death
what it can be, a death that is freely accepted.'

Fragment 21

One day he finally decides to take to the laundry the damask tablecloth he extracted from the dustbin that Peggy left outside her empty house. When he gets it home, he opens it out to see whether the cleaning has restored its satin-like smoothness and ivory colour. The wine- and sauce-stains have been washed out, but not completely; they have faded into faint rings of pale pink and amber superimposed on the patterns in the cloth. They are suggestive of some inchoate bloom, like faded flowers emerging from the morning mist.

Having studied at length these floral designs and traced their indistinct outline with his fingertip, he re-encounters them in his dreams the following night.

He sees Peggy as she was when they were last together: wearing her light flowing dress, spangled with tiny flowers and butterflies. And suddenly, as in his adolescent dreams when he burned with desire for Peggy, he sees her start to sway, to twirl round in circles – not increasing fast, but more widely expanding – and her dress begins to ripple gently, to rise and open up in a big corolla. And now this dress, dotted with little flowers and insects, is floating round the middle of her body, encompassing that white belly, those slender hips and bare buttocks with a halo of softly radiating light. Her sex is no longer the shape of a sun-like thistle, as in the past, but of a peony with its countless petals closed.

And now the flowers detach themselves from the fabric, the butterflies take flight and dance in slow motion; the dress evaporates, leaving only a milky nimbus, veined with streaks of orange-yellow, round the naked woman's waist. Her breasts are beautiful, small and perfectly rounded, their areola the colour of fresh hazelnuts and the nipples themselves like the

hazelnut kernel. Her skin is sprinkled with little freckles, unless they are the ocelli of butterfly wings. With a quivering of petals the peony opens up, a mere fraction. And there the dream ends, unfulfilled.

No, the dream does not end, it takes another turn, becomes transformed. Peggy has disappeared, or rather her body has faded to the verge of invisibility, rather as the washed-out stains on the damask have become misty hints of colour, floral intimations. Only the peony remains, like a clenched fist relaxing, then closing again. No, like a beating heart.

He cannot see Peggy any more, all he can make out is a heart palpitating in the emptiness, just surfacing out of the milky fog. And he can hear the dull monotonous pounding of this suspended heart. The more visually spare his dream becomes, the more it gains in resonance.

Is it enough to dream of someone for that person then to remember you and make contact after a long silence? The fact is that a week later Magnus receives a letter from Peggy. For all these months, she writes, she has remained devastated by what happened during that dinner at her house, already then no longer a home to her. But devastated by what exactly, she wonders. Her twofold shame, redoubled by having to confess to the shame she had felt since Tim's death? Remorse for her own culpability for that death? Her inability to provide any explanation whatsoever for the tragedy? Or bewilderment at the strange phenomenon that occurred that evening in Magnus's presence, which she still does not understand? She does not believe in ghosts or haunted houses, but she does believe in the strength of feelings, good or bad, when they rise to a pitch of intensity; in the power of emotions, especially if forcibly concealed; in the energy of certain ideas, especially if brutally silenced. The flesh then saturated with all this contained energy, and the heart too sore from things unspoken,

from lies, fears, and regrets, gasping for breath eventually cry out all that could not, would not be said. Yes, for months she has lived in a daze of stupefaction, struggling to keep up appearances in front of her colleagues and students at the institute where she teaches. But three days ago all of a sudden the weight bearing down on her was lifted, she was released from the permanent grip of anxiety. She does not know how or why, and is not attempting to explain it. She is simply noting the change, the relief; this first step towards deliverance. But, for all that, without forgetting or denying or refusing to acknowledge anything of what happened – her responsibility for Tim's death, her gradual aversion towards him that turned to repulsion, then cold deadly hatred. Have you ever experienced that slow distortion of love, she asks Magnus, and adds that it is something she hopes he has never had to live through, and never will.

And in these last three days, she continues in her letter, she has the impression of having covered more ground than in several decades. The impression of picking up again, moving forward, without trying to hide her guilt behind her back any more, but bearing it in her arms like some small animal certainly mortally wounded but that she does not despair of saving.

It is in order to tell him all this that she is writing to him today, and to thank him for having, knowingly or not, stoked the madness that was smouldering inside her, making it burst into flame, burn itself out. And never mind, she adds, if all this seems confused, it was something she had to tell him.

Finally, she writes, if he should ever have the desire to visit Vienna one day, she would be delighted to see him again. She even goes so far as to say she is renting an apartment big enough to accommodate guests.

Her letter ends with this invitation, both warm and vague. Magnus soon makes it definite: he decides to go to Vienna the following month.

Sequence

 'A grey ox in China
lying in the stable
stretches its backbone
and at the same moment
an ox in Uruguay
looks round to see
if someone has stirred.
Flying over both of them
through day and night
is the bird that silently
circles the planet
and never touches it
and never comes to rest.'

 Jules Supervielle, 'A grey ox in China . . .'
The Innocent Convict

Fragment 22

The first time they faced each other naked, Magnus felt the ground shift under his feet. All his dreams from the past suddenly gathered in a solid mass shattering the reality that had finally come into being. Peggy's body was already so familiar to him this sudden revelation seemed like an absurdity, an assault. And his desire for her was panicked to the point of collapsing into impotence. His own body failed him.

Lying beside her on the bed, he hardly dared look at her, caress her. His vision was blurred, with images of Peggy's nudity contemplated in his dreams overlaying the very real vision that presented itself to him; images that rippled over her skin, making it untouchable. Peggy took his hand and laid it on her breast, gently holding it there. She did not say anything. She smiled at him, waiting for the emotion that paralysed him and made him tremble to subside. But his emotion intensified. Magnus felt his hand grow heavier, practically weld itself to Peggy's breast. And his sense of touch became confused with his hearing. His palm could hear her heartbeats and these pulsations spread through his whole body, all listening and resonance. He shivered as though in the grip of a high fever.

This heart beating beneath his palm, ringing in his blood, was not just that of Peggy now, it was a palimpsest of sound – in which May's heart released indistinct echoes, calling to him, reminding him.

He had made love with other women since May's death, but none had caused such a jolt to his memory. Women briefly desired, very fleetingly and casually loved; occasional mistresses, purveyors of pleasure and oblivion, no threat to his enduring love, the woman who had enchanted his life for ten

years. May's place as friend, lover and accomplice was left unoccupied. A place set very high, beyond reach: high up in the sky's sheer blue of empty space, amid the dreadful quiet and ashes.

And now this vacant place was suddenly destabilized, and to the question that had tormented him for years – Did May love me? And did I love her? Have I ever loved anyone? – Magnus was given an answer: a calm and profound yes. He wept silently for a long while. And as they flowed his tears dampened the sheet, Peggy's hair, they also dampened the noise that filled his palm and pulsed in his flesh, making it sound softer. Peggy brought her face right up close to his and kissed his eyes, then licked at his tears, like a kitten. And licking at him, she laughed, then hummed a song.

Then the palimpsest heart disclosed other resonances, yet fainter than the earlier ones. They unfurled in tiny waves, barely perceptible, as if originating from a long way off, from an earlier age. From even before his birth perhaps, from the time when his body was slowly forming in the liquid darkness of his mother's body.

And he fell asleep with his hand resting on Peggy's breast. When he woke, all echoes within him had fallen silent, no thought constrained his movements, his desire was free. And his body this time did not fail his desire.

This scene took place several years ago now, but it continues to glow in Magnus's memory like some permanently illumin-ated night-light. He knows when and where the scene took place – one evening in June 1974 at Peggy's apartment in Vienna. But as this event was the blossoming of an old desire, long felt then forgotten, gradually revived and again thwarted and deceived, to him it feels timeless, both very distant and very close, always vivid.

They have never discussed the tragedy that occurred on the cliffs of Dover, and Magnus says very little about his own

past. They each bear their respective burden of time with discretion. Nothing is denied or cancelled out, but they know it is pointless to try and explain everything, that you cannot share with another person, however close, what you experienced without them, outside of them, whether it be love or hate. What they share is the present, and their respective pasts settle in silence in the radiant shadow of this present.

The day they visited the crypt in the Church of the Augustinian Friars the inevitable reticence that surrounds consummated passions, because of the impossibility of accurately conveying them in all their subtlety, intensity and contradictions, suddenly became pathetically apparent to them as they looked on those urns containing the hearts of the Hapsburgs. In a small alcove steeped in a wan light and protected by a grille, some fifty urns of wrought silver of various sizes are lined up in two semi-circles, one above the other. Once living hearts that beat with pride in the breasts of empresses and the bodies of all-powerful emperors. That beat with passion, with fear and anger too, with jealousy, desire and sorrow, shame and hope. Of these aristocratic hearts that each in turn, in gold and steel, in splendour and in blood, rang the hours of the Germanic Holy Roman Empire, there now remains a cohort of old shrivelled muscles in formaldehyde, keeping vigil round a void. Thus do the living hide away in a corner of their memories reliquaries of affections, hard feelings, joys and sorrows that are more or less played out.

During the first two years of his relationship with Peggy, Magnus returned to London frequently to spend time with Lothar, who became ever more diminished by illness.

Progressively losing his eyesight, his voice, and to almost the same extent the ability to walk, Lothar remained seated all day long in his armchair by the window of his study. But far from enduring these infirmities as so many detestable privations,

he turned them into an abrasive source of strength. From his paralysis he drew a profound sense of patience, a limitless and measureless readiness to wait in expectation of nothing, if not the unsuspected. And his immobility appeared serene, totally occupied with lengthy meditation.

In his loss of the power of speech he tasted the bitterness of that inner silence where language unravels, with every word acquiring a new weight, a greater resonance. And his silence was vibrant. In the loss of his eyesight he discovered another way of seeing: seeing behind the visible. A brightness spread over his practically inert hands and his blind man's face. His smile especially grew luminous. As soon as anyone came into his study he would turn his face towards the visitor whom he would recognize – from their way of opening the door, their footstep – before they had even uttered a word, and he would greet them with a smile. Many things were conveyed by this smile, everything he could no longer express in words. And this 'everything' concentrated in the extreme, distilled to nothing, laid bare the depths of his being: the intelligence and modesty of a goodness without regard for itself.

Consigned to dwell in the silent darkness of his body, he actually conducted a multiple dialogue: with the living and the dead, with himself, and even more so with that element of the unknown whose discreet and yet sovereign presence he sensed within him.

One evening that element of the unknown summoned him wholly to the other side, beyond the visible world. Magnus was not there; he did not arrive until the day of the burial.

Erika's husband delivered the funeral sermon, developed from two biblical texts that Lothar studied constantly towards the end of his life: chapter 19 of the First Book of Kings, in which the prophet Elijah climbs Mount Horeb, and the Sermon on the Mount from St Matthew's Gospel. Two texts that invite the intellect to undergo a 180° revolution, that require faith to be radically purged of naivety, and the action

following from this spiritual rupture to be carried out with as much flexibility as rigour, as much coherence as boldness.

The day after the funeral Myriam gave him a box firmly tied up with string. 'Don't open it now,' she told him with an abruptness typical of shy nervous people, 'wait until you get home. I made it for you, just for you.' Faced with Magnus's look of amazement she added, 'It's not an artwork, it's something much more than that. Or perhaps worse . . . I don't know.' Then, as he was about to thank her for this mysterious gift, she interrupted him. 'No, don't thank me. Wait and see what it is before deciding whether you have any reason to thank me or reproach me. But please don't open it until after you've left London. And don't mention it to anybody, especially not my parents.' With these words, she made her escape.

He respected Myriam's wishes and did not open the parcel until he was on the plane taking him back to Vienna. But he had no sooner opened it a fraction than he closed it again. For the entire duration of the journey he remained motionless in his seat, his gaze turned towards the window, his hands clutching the box on his lap.

The sea, below, of steel grey veined with green. And down there, land, with miniature towns and villages, fields divided up into yellow or brown rectangles, dark, densely textured forests, lakes and rivers reduced to sparkling puddles and ribbons of silver-grey. Then tumbling rocks, of mountains black and white invested with placid menacing power. And the clouds at times covering everything, at times with rifts opening up to pull the gaze into vertiginous depths.

And in the cardboard box, Lothar's death mask.

Resonances

'This is my brother, Lothar,' Thea had said.

Lothar, the repudiated brother, passed over in silence: an exile. A stranger who turned up out of nowhere.

'The life of a saintly man consists more in receiving from God than in giving, more in desiring than possessing, more in becoming pious than being pious,' declared Martin Luther.

Lothar Schmalker possessed nothing, and he gave in abundance of his welcome poverty.

'We've got some difficult days ahead. But it really doesn't matter with me now, because I've been to the mountaintop. And I don't mind. Like anybody, I would like to live a long life. Longevity has its place. But I'm not concerned about that now,' declared Martin Luther King on the eve of his assassination.'

Pastor Lothar Benedikt Schmalker's longevity required him to climb very slowly the dark side of the mountain.

'I must be certain of being in the hands of God and not those of men. Then everything becomes easy, even the harshest privation . . . The important thing is that everything that happens to me finds faith in me . . .' wrote the prisoner Dietrich Bonhoeffer.

Lothar Benedikt placed his infirmity in the empty hands of God.

> *Black milk of first light . . .*
> *We dig in the air a grave . . .*

'All these years without any news of you . . .' Lothar had said to Magnus.

From now on, there would be no more news of Lothar.

Fragment 23

After Lothar's death the disquiet Magnus feels in Vienna only increases. Certainly the town is attractive, enchanting even, with its atmosphere such a subtle mixture of melancholy and hedonism, conformity and frivolity, bitterness and irony, courtesy and arrogance. It is pointless to criticize the Viennese, they do it very well themselves, their self-criticism as biting as it is subtle. But Magnus sometimes detects here and there, in the course of a conversation overheard in the street, in a café, on the tram, strains of nostalgia for the great heroic opera of Nazism. Peggy has no sense at all of this defiance, she likes living in this city, and would be willing to extend her stay here indefinitely. However, after seven years in Vienna she finally looks for a teaching post in another country, and lands one in Rome.

Magnus likes these periods of disorder and uncertainty that precede moving to a new home. Time no longer obeys the clock, familiar space is turned upside down, habits are unsettled. Day by day objects disappear into cardboard boxes and packing-cases accumulate along the walls of the apartment where footsteps and voices resonate differently. The place you are preparing to leave suddenly acquires the charm of nostalgia whilst your curiosity about the new country you are moving to increases. Opposites become tangled, desire switches between here and elsewhere, and the present quivers with gentle excitement, tugged between the past and the unknown future.

The days are still long and the evenings mild in this late summer. One afternoon about five o'clock, Magnus brings home

a bottle of champagne to celebrate the completion of their packing. He spreads over some of the packing-cases the ivory damask tablecloth faintly patterned with pink and orange flower-like stain-rings and sets out two champagne glasses together with an assortment of pastries, for which Peggy has a weakness. A pearly white rose with a subtle fragrance stands in a glass vase. This variety of white rose has the lovely name of Schneewittchen, meaning Snow White; it is also sometimes called Iceberg. Teddy bear Magnus is also part of the decor, propped up against the bottle. He has aged a little, his head slightly tilts towards one shoulder, the wool of his muzzle is rough, the leather of his ears and paws is cracked, but his eyes have kept their soft buttercup gleam. He does not have a scarf round his neck any more, but a little cord with a tiny red velvet bag hanging from the end of it.

He is not merely part of the decor, he is involved in this festive occasion, as he has always been involved in his name-sake's life. As for the tablecloth, it is not there to recall the painful farewell dinner at the house in London, but for having offered a glimpse of a dream of love that has become a total reality. This is a time to look to the future, not to the past and its ghosts.

When the bottle of champagne is empty Magnus fills it with water in which he puts the Schneewittchen stem, whose petals have a pale pink hue in the light of the setting sun. He repositions the soft toy against this vase. Then he removes the velvet pocket tied round the teddy bear's neck and offers it to Peggy. She opens the little bag and extracts a ring from it. A band of pure gold with a finely wrought zigzag inlay of red rubies. She stares at the ring lying in the hollow of her palm as if it were some unusual plant or insect, and not a piece of jewellery. Magnus takes it and puts it on her ring finger; but her finger is too thin, and so is her middle finger; so he tries it on her index finger. Only on this finger is the gold band not

too loose. 'Well,' says Magnus, 'a finger that is used to point to everything, even a long way off, and also to call for silence, is a very appropriate one on which to wear a perpetual engagement ring.' Inside the band he has engraved 'You'. Just that one word, which he often uses to address Peggy – 'Hello, You', 'Goodbye, You', is how he usually greets her, or 'Hello, You?' when he telephones her. You, a name reserved solely for Peggy, a personal pronoun replete with desire and lent an importance that does not, however, exclude an element of self-mockery, Magnus making fun of his own besotted happiness.

He suggests dining at a restaurant nearby, but she would rather go to the Heilgenstadt district on the other side of town, not having been there for a long time. It is quite a long journey, and by the time they get there darkness has fallen, lanterns have been lit in the courtyard of the tavern they go to, and already the long wooden tables set up under the chestnut trees are nearly all occupied. Peggy looks round and spots a small table on the far side of the courtyard that some people are just about to leave. She points out the free table with her gold-ringed index finger zigzagged with translucid red.

The lanterns cast a slightly acid light that bleaches the shadows beneath the boughs in a pale ochre haze, glistens on the faces of the diners and makes the white wine in the glasses and carafes sparkle with shimmering hues of citron, honey, or pale gold.

The wine trills in the glasses, strikes a fresh note in the mouth, and soon sings beautifully in a few joyous throats.

The diners at the table next to Magnus and Peggy are on fine musical form, interrupting their chatter punctuated with noisy laughter to break into song, moving on from ballads to lieder, and returning to some love songs. One of the singers has a deep strong voice, albeit a little husky with

age. A bass baritone voice to which everyone listens with pleasure.

'What's wrong? Don't you feel well?' asks Peggy, suddenly distracted from listening. Magnus is sitting rigid on the bench opposite her, drained of colour, with staring eyes. He recovers himself and says, 'It's nothing . . . the wine, the heat . . . a wave of tiredness.' He makes an effort to smile and adds, 'Ssh, listen to the singing.'

He can no longer fight the need to look at the man whose voice dominates, eclipses everyone else's. He slowly turns towards the next table, seeking out the baritone. He sees a man of medium build, aged about seventy. A narrow band of white hair emphasizes his suntanned scalp. He can only see him in three-quarters profile. He studies his nose: a short very straight nose. But a nose can be operated on, fixed, thinks Magnus. The man is wearing tortoiseshell-rimmed glasses with dark rectangular frames. Magnus cannot make out his eyes, or the shape of his mouth, which is half-concealed by a moustache that runs into a closely trimmed beard, forming a white oval under his nose down to his chin. So he tries to see his hands. Age has left its mark on them, the veins are prominent beneath the speckled skin, but the observer's gaze is struck by their appearance: these hands are beefy with impeccably manicured fingernails.

Magnus rises and walks over to one of the waiters. He tells him he would like to surprise his wife, who is particularly fond of the Schubert song '*Geist der Liebe*'. Could he ask that man who has such a fine voice whether he knows the song, and would he agree to sing it?

'Ah, that Walter!' exclaims the waiter, laughing. 'He can still sing amazingly well, can't he? And nearly eighty he is! And it's not just his voice that's well preserved, so is his taste for pretty women!'

'You know him? What's his name?'

'Walter Döhrlich. He's a regular customer. Often comes here. Lives in the neighbourhood. Well, I'll go and convey your request to him. He'll be delighted to sing for a beautiful stranger.'

Magnus returns to Peggy, positioning himself so that he gets a better view of the man by the name of Walter Döhrlich. The waiter approaches him and whispers something in his ear. The man smiles, looks round, surely seeking out the charming wife to whom '*Geist der Liebe*' is dedicated. He gets to his feet, the better to project his voice, and starts to sing.

'*Der Abend schleiert Flur und Hain / In traulich holde Dämmerung* . . .'[1] The man stands very upright in the pale light under the chestnut tree, his mouth opens wide, a dark chasm of mellifluousness. With the stench of death. '*Die Baüme lispeln Abendsang / Der Wiese Gras umgaukelt lind . . .*'[2] He sketches in the air the slow gestures of a seed-sower. A sower of blood-letting, terror, ashes. Magnus can see again the purple velvet drawing-room curtains in the house by the heath. And in the folds of the curtains appears the spectre of a little boy. '*Der Geist der Liebe wirkt and strebt . . .*'[3] The mouth of darkness ringed with an oval of white modulates the incantation to 'the spirit of love'. Every precisely articulated word falls on Magnus like a drop of acid, he clenches his jaws and fists to suppress a fierce desire to cry out. Having often heard them in the past he knows every one of these words, this tune, so well, – '*Geist der Liebe*', Thea's favourite lied.

The curtain grows heavier, its folds deepen into long black and purple trenches with figures in their thousands trembling at the bottom of them. Peggy listens, enraptured, to this improvised concert under the chestnut trees in the tavern garden. The evening of her unexpected engagement is a joy

[1] Evening veils meadow and grove/ with fair intimate dusk

[2] The trees whisper evensong/the meadow grass gently sways . . .

[3] The spirit of love acts zealously . . .

of utter charm and delight, a feast for all the senses. She raises her glass and unobtrusively clinks it against Magnus's before bringing it to her lips. She smiles as she sets it down again, her left cheek dimpling, her lime-green eyes sparkling. Peggy: first body he desired, first mouth he kissed, a body lost and found, embraced at last, and penetrated, caressed, explored, and still desired. Peggy, song of the flesh, love incarnate.

'*Ein Minneblick der Trauten hellt/Mit Himmelsglanz die Erden-welt.*'[4] The mouth of darkness closes slowly, almost regretfully, in a sensual sigh. The elderly gentleman with the white goatee beard and coronet of white hair has certainly sung with talent, with a suave passion whose warmth delicately diffuses through the garden, enchanting all the customers in the tavern, and a spate of applause punctuated with a few enthusiastic bravos hails his performance.

This end-of-concert commotion suddenly brings Magnus back to reality – the curtain disappears, his memories recede, his emotion subsides, and everything inside him falls silent. He was surely mistaken, his misapprehension giving rise to a delusion. Despite a few admittedly very disturbing similarities, this dapper seventy-year-old amateur lieder-singer is not, could not possibly be, former SS Obersturmführer Clemens Dunkeltal. The fugitive Dunkeltal died ignominiously in the port of Veracruz more than thirty years ago. Magnus reassures himself, dispels his suspicions, and finally relaxes.

'It was for you he sang that song,' he tells Peggy, and explains how he approached the waiter. But he does not admit the real reason for his initiative, and when a radiant Peggy laughs at this supposed subterfuge, he feels a bit of a heel.

[4] A loving glance from the beloved casts/heavenly light on this earthly world.

The success scored by the elderly bass baritone rekindles the liveliness at the table where he is sitting: the hero, in his element, is toasted by all around it. Suddenly Magnus, who is no longer paying him the febrile attention he directed at him all the time he was singing, notices a man who has come up behind Walter Döhrlich. A clean-shaven man of about forty with brown hair and a crew cut. He has placed one hand on the singer's shoulder, a gesture conveying as much pride as affection. The pride and affection a son feels for his father. Which, judging by what they say to each other, is what they are. The resemblance between this man, named Klaus, and Walter Döhrlich, is not obvious; however, the resemblance between him and Clemens Dunkeltal at the same age is glaring. Apart from the hair – Clemens Dunkeltal's was lighter and rather fine whereas this man's is thick and brown – everything else tallies: the same stockiness, even the same bearing, the same aquiline nose and thin-lipped mouth, the same oblique line between arched eyebrows, the same square chin. Though old Dunkeltal, now balding, with his nose fixed and his chin cleverly rounded with a cleverly-trimmed goatee beard, has made zealous attempts to disguise himself, the job is only half done: he has neglected to change the inflections of his voice when he sings and his German accent when he speaks, and he has not noticed that his son has become the mirror image of him at a younger age. So here he is, betrayed by what he is most proud of, his beguiling voice and his beloved bastard son, Klautschke of the Berlin Zoo.

A great calm settles on Magnus, as if all his rage and emotion were consumed during the song. The shock of this revelation has lessened, and his suspicions, momentarily allayed, return in force, verging on certainty. But to be absolutely sure he needs one last incontrovertible piece of evidence. Magnus asks Peggy if she could find a piece of paper in her handbag. She tears a page out of a little notebook and hands it to him, along

with a pen. He writes a few lines on this piece of paper, folds it in four, then suggests to Peggy they go home. He orders a taxi which they wait for in front of the tavern. As soon as he sees the car arriving, on the feigned pretext of having left the pen on the table he tells Peggy to wait for him in the taxi and hurries back into the garden. He gives the waiter a tip and asks him to convey another message to Walter Döhrlich. He positions himself not far from the Döhrlichs' table, by a chestnut tree whose lower branches make his presence more discreet, in order to observe the scene about to occur.

The waiter hands the note to its intended recipient, who takes it from him, laughing. He waves the message about, hinting it must be a billet-doux from the lovely lady charmed by his singing. The old poseur sees himself as Orpheus, and the whole table takes up this bantering. He unfolds the note and reads the contents. His smile freezes, his face pales, his features turn leaden. His table companions observe this and their bantering abruptly ceases. He abruptly raises his head, his chin jutting forward. He scrunches up the paper in his fist, then whips off his glasses and scans the area around him, his eyes creased in fury. But there is also terror in his gaze. The gaze of an unmasked imposter. The gaze of Clemens Dunkletal at the time of his flight when the war ended. Like the voice, a gaze is an unfalsifiable signature.

Magnus has the proof he was looking for. He slips away and hurries back to rejoin Peggy in the taxi, returning the pen he had stuffed into his pocket. He is careful to direct the driver to a neighbourhood far from where they live, explaining to Peggy that he wants to take a ride round the centre of town.

He says nothing of what has just happened, he is too staggered – at having seen not a ghost but a scum-bag, very much alive and well, a solid lump of flesh owing its self-preservation to the inexhaustible greed and cynicism of the timeserver. A scum-bag, but no less a member of the ordinary human race.

He does not yet know what he is going to do, his mind dwelling on the words he hastily scribbled on that piece of paper, trying to work out what he meant by the vague threat he had formulated.

Throughout the journey he squeezes Peggy's hand in his, to keep in contact with that aspect of the human race that is light and beauty.

Note

'For a man who has been dead for more than thirty years you still sing very well, Dr Clemens Dunkeltal. It's true, you've had several changes of voice: the voices of Otto Keller, Helmut Schwalbenkopf, Felipe Gomez Herrara. And perhaps a few others besides. Not to mention, of course, the voices stolen from your thousands of "patients" at Dachau, Sachsenhausen, Gross-Rosen, and Bergen-Belsen.

All those voices, Dr Clemens Dunkeltal, would have a lot to say about your "spirit of love". Rest assured, they will have their say. Very soon.

For it would be a pity if a talent as great as yours were to remain unknown. Don't you agree?

Until we meet again, then, in the very near future.'

Fragment 24

Clemens Dunkeltal has vowed that the author of the message delivered to him, which he immediately reduced to a little ball of paper, will be made to swallow it. And, not knowing the name of this author, he wastes no time in finding out. He does not reveal to his table companions the contents of the note, which he passes off as a disparaging comment from a fellow diner obviously allergic to his singing, but he makes enquiries of the waiter, who does not understand what has happened.

'But it was the same man who requested '*Geist der Liebe*' to please his wife,' he says, 'and he seemed very happy about it . . .'

Then a young girl sitting at the end of the table intervenes. 'The wife – wasn't she the red-head in a blue and black polka dot dress, sitting over there?'

The waiter nodded.

'I know her,' the young girl continues. 'She's an English teacher, I was in her class two years ago.'

And the young girl gaily babbles on in English, diverting attention from the incident, in the end of no great interest. But Dunkeltal junior, who has guessed that the incident was of some importance, asks for the name of this charming English teacher with the moody husband. Margaret MacLane. No sooner has he been given the name than he offers to take his father home, pleading tiredness.

A taxi drops off a couple in a little street close to the Oberlaa baths, and drives away. The street is deserted at this late hour, the air has just begun to cool. Magnus halts for a moment on the edge of the pavement, searching his pocket for his keys. He has his back turned to the road, while Peggy stands beside

him, facing it. It is then that she sees a car that was lying in wait nearby come hurtling towards them. She cries out and gives Magnus, still rummaging in his pockets, such a hefty shove that he is pushed aside just far enough so that the oncoming vehicle only strikes his hip. He falls backwards into the dustbins lined up there. As he falls he hears a dual sound, a thud and a shriek of equal intensity – the sound of a body run over and thrown into the air, the shrill cry emanating from that body. Lying on his back, stunned by the impact, he beholds a bewildering, absurd image: Peggy falling from the sky and hitting the asphalt three metres away from him. The car does not stop, does not even slow down. But a dustbin has rolled into the road. The car swerves. One of its wheels bumps against the edge of the pavement. It drives on regardless. It is going so fast the driver loses control just as it turns the corner of the street. And that is where it skids and goes crashing into a lamp post.

Magnus wants to get up, but is unable to. He feels pinned to the ground by a burning pain in his hip. He calls out to Peggy, lying curled up in the gutter. He drags himself over to her. People emerge from the building and come running over to them. All he can see around him are feet. There is the sound of a police siren in the distance, or of an ambulance. He reaches his hand out towards Peggy, touches her hair. It feels wet and reddens his fingertips. There are voices talking above him, but he does not understand what they are saying. He is listening only to Peggy's laboured breathing. Their faces are right up close to each other. He can see Peggy's lips moving feebly. 'Tim?' she murmurs. Her voice sounds both plaintive and questioning.

Two men are pulled out of the car that smashed into the lamp post. The driver is dead, killed instantaneously, his chest staved in by the steering wheel, his face lacerated by the shattered

windscreen. His passenger is seriously injured. In the hollow of one of his hands, now limp and inert, a ball of paper is found. No one gives it any attention. The crumpled note falls among the shattered glass, metal, pools of blood.

Peggy MacLane and Klaus Döhrlich are buried the same day, in two different cemeteries in town. Neither Magnus nor old Döhrlich attend their burials, both are in hospital. Magnus has a fractured hip and femur, the other a shattered spine.

In the apartment left unoccupied, near the Oberlaa baths, dust gathers on the packing-cases, unwashed glasses and damask tablecloth. The Schneewittchen stem stands stark in the emptiness, its dried leaves and petals forming a delicate scree on top of Magnus the teddy bear's head and round the champagne cork lying between his paws.

Resonances

'Magnus? Who is Magnus?' May had asked.

Magnus is a teddy bear with worn fur, covered with dry shrivelled rose petals. A stale smell of dust emanates from him. Schneewittchen, the rose was called.

Magnus is a man of about forty, broad-shouldered, with an angular face. He walks with a limp. He gives an impression of solidity and despondency, of extreme solitude. Iceberg is the other name for that rose.

Loneliness whose big heart is clogged with ice . . .

'Have you ever experienced the slow distortion of love?' Peggy asked him in a letter.

No, not the distortion. All Magnus knows of love is the crazed waiting, doubts and anguish, and the bliss. A great deal of bliss. And the chasm of grief, the devastation of loss, twice over. But the second time, it was he who opened up the chasm.

'I hope it's something you've never had to live through, and never will,' she added.

He has done something worse than let love turn to revulsion – he has offered it up, live, for slaughter, by mistake, and through anger, in the name of a cold hatred suddenly turned furious, incandescent. A hatred stronger than his love.

My wits begin to turn.
Come on, my boy. How dost, my boy? Art cold?
I am cold myself.

'What about May, what's become of her? And Peggy? Did they stay behind in Comala?'

May, with your long black braid, Peggy, with your red-gold hair.

She and You both stand there, elsewhere, nowhere, *each in our degree*:

> 'What do you mean to do?'
> *. . . let Time go by till my change come.*
> *Black milk of first light . . .*
> *We dig in the air a grave . . .*

Fragment 25

When Magnus leaves hospital, equipped with a walking stick, it is already well into autumn. His disability is going to qualify him for a pension before long. Thus concludes the dramatic accident of which he was a victim. For so it has been classified – an accident, not a killing.

There will be no trial. Clemens Dunkeltal will be tried neither for his last murder nor for the innumerable crimes he perpetrated in the past. Seated in the armchair he is confined to as an invalid, he has just committed his last crime by getting one of his faithful friends to administer a poison that will allow him to make a cunning exit behind the mask of the charming Mr Döhrlich. That Walter! The whole affair is suppressed even before it has had time to be picked up, to become known.

What good will it do to try setting himself up again as the dispenser of justice? Magnus has lost everything by having too impetuously, presumptuously, played at being detective and avenger. He went rushing in like an enraged ram charging an obstacle harder than its own forehead. The obstacle finally gave way, reduced to smithereens, but it brought everything down with it. Magnus is now no more than the witness of his own misdeed, his own insane conduct. Witness for the prosecution, with no mercy for himself.

Magnus closes the door to the apartment for the last time. Everything is in order. Everything – in this case, nothing.

The place has been cleaned and emptied: the order of nothing prevails. Moving has turned into clearance. The furniture, household goods, and odds and ends have ended up in a sale room. Peggy's clothes he has wrapped in the damask cloth,

and this shroud weighing as much if it contained her dead body he has thrown into the Danube. A river grave for Peggy's flowery dresses, striped dresses, polka-dot dresses, butterfly-patterned dresses, cardigans, shawls, shoes and underwear.

The Dunkeltal affair is laid to rest, buried in the respectable Döhrlich family vault where father and son lie side by side in everlasting complicity.

Meanwhile the body of love decomposes in silence, in the coldness of the earth, perishing with loneliness. Its grave is modest, very stark. Its outer layers of silk, cotton, satin, Tergal and wool, its smell, its perfumes dissolve in the opaque waters of the river.

Love's beautiful body and its fabric outer layers stripping away desire, love's crazed body and its sensual flesh rot in the mud, in the mire.

Once again Magnus is starting out from zero. As when the Gomorrah hour struck – an ever abysmal moment on the dial of his life. And this zero is not only burdened with very crowded memories, and fraught with loss, it is seared with remorse and helplessness.

A complete nothing reigns inside him, and this nothing creates neither order nor clarity. It leaves in his spirit only confusion and a taste of dust. Shame and remorse are not so quickly dispelled.

He leaves Vienna, his only luggage being two bags, containing clothes, a few books, some letters, his teddy bear, and Lothar's death mask.

He does not return to London, nor does he move to Rome. He sets off with no particular destination. It is enough for him to know where he does not want to go: Vienna, London, Rome, three cities from which Peggy's absence banishes him.

'Magnus, an unidentified Icelander!' Scott had suggested one evening. Magnus could at last go to the country presumed to be the land of his birth – but to seek whom? To find out what? The enigma of his birth is now less of a torment to him than that endless boundless night when his love came to grief.

He is looking for a neutral, remote place, a place of a water clock nature, where he can *let Time go by till his change come*. What change? He does not know, but for him this not knowing is now the only adventure worth while.

He goes to France, where he avoids the big cities. He flees the crowds, the noise, company of any kind. Passing through Morvan, he finds the part of the country in which to establish his solitude. He moves into a house reduced to two rooms and attached to a barn and a stable more spacious than the house itself, near a small village called Bazoches with a château rising above it. There is a broad view from this place, extending over fields and forest, and opening out in the distance over the hills of Vézelay. These names suggest nothing to him. Magnus is a stranger to this land, and to its history, and this ignorance suits him. He has come to cleanse his gaze, purge it of an excess of images. He is just a bear-man wanting to hibernate.

Echo

You hear rustlings. Laughter . . . *after* . . . Time-worn laughter, as though weary of laughing . . . *weary of laughing* . . . And voices wasted . . . *wasted* . . .

All this you hear . . . *you hear* . . .

The trees whisper evensong, the meadow grass gently sways . . .

You hear rustlings . . .

The spirit of love . . . heavenly light on this earthly world . . . *earthly world* . . .

The day will come when these sounds . . . you hear *these sounds will die* . . .

will die you hear . . . *die*

You hear the silence you hear
 nothing . . . *hear nothing* . . .

Fragment 26

Magnus's hibernation lasts a long time, several seasons, but generates no torpor, no passivity. It is totally taken up with doing a job no less slow than intangible: allowing time to decant, day after day, hour by hour. This is a process similar to erosion, or the formation of stalactites in a cave; a process that demands fantastic patience, concentration, scouring of the mind. A laying bare of oneself.

He walks a great deal – a step-by-step decanting. He rises early and goes out into the countryside. He has a slightly lurching gait, and always carries a wooden staff for a walking stick. The area over which he rambles describes a kind of huge star shape, with points extending in a zigzag. The local people are used to seeing his limping figure go by, along the paths, down the streets, through the villages. No one knows where he comes from, who he is exactly, or what he is doing in this remote part of the world. He is no talker, and does not give anything away. But he is no bother to anyone, polite to all. Not knowing what this foreigner's country of origin is, people deduce from his accent and taciturn nature that he must come from northern Europe, and that is how he is referred to: 'the guy from the North'. Or sometimes, 'the guy with a limp'.

One day he penetrated deep into a forest on the other side of the river that winds through the Massif, and emerged into an abandoned clearing. Lined up around the edge of it were bell-shaped constructions of straw intertwined with slender branches, set on planks: old-fashioned beehives, such as Magnus had never seen before. It was cold that day, a dry frosty cold that silvered the dormant hives. In the centre of the

clearing stood a small stone structure covered with moss: a niche built to house a small statue – but the statue was gone. Inside the empty niche a long brown-red slug slowly crept forward. Magnus sat on this mound to rest a while. He was soon wondering at the sounds around him. They were different from those he had grown used to hearing deep in the forest. These sounds were more nuanced, more modulated, as though someone were trying to play a wind instrument, inexpertly and yet with a certain grace. He peered into the undergrowth, strained his ears, but detected no human presence. Yet this somewhat hushed melody was coming from very close by. He rose to examine the place, and finally discovered the source of this music: some beech trees with strangely carved trunks, hollowed out in places, through which the wind whistled as it blew through them. He thought he could make out in the trunk of one of these carved trees the outline of a body, an indistinct face with a faint smile on it, and a rough-hewn pair of joined hands. In another, the figure of a man holding a trumpet. And in yet another, a relief carving of a heart; and there, the horns of a ram. But these beeches were dead, some still standing, others lying on the ground, all overgrown with ivy and brambles. He would have returned to this wood but he could never find his way back again.

He also spends long hours motionless – a drop-by-drop decanting. He has cleared out the barn but does not furnish this vast space with an earthen floor. The only function he assigns to it is to serve absolutely no purpose. An extravagant uselessness, gratuitousness, a sanctuary dedicated to emptiness.

There is a chair by the door. Holding the back of it, Magnus picks it up when he enters the barn and places it sometimes in the middle of that emptiness, sometimes against a wall, or in a corner, and there he sits, with his stick planted between his knees, and his hands folded over it. He is capable of

remaining like that for hours, appreciating the silence, enjoying the effects of the gloom and the light filtering through the ill-fitting slatted walls, observing the barely perceptible swirl of dust in the rays of light, the work of a spider spinning its web in a nook. Occasionally a field mouse comes scampering by, sniffs around, turns away and scurries off. Birds too venture into his vacant sanctuary, some have built their nests here. When he leaves, he always puts the chair back by the door.

In the church at Bazoches is the tomb of a certain Vauban. Magnus finds out who this man was, learns about the extent of his achievements, the multiplicity of his interests, his genius, his courage – a remarkable man, who fell into disgrace on account of his exceptional intelligence, boldness, generosity of mind, having been thoroughly exploited by his king, whose only greatness and connection with the sun lay in the epithets he usurped.

The body buried here has had its heart cut out – Napoleon had it entombed in Les Invalides a century later. Magnus thinks back to the crypt of the church of the Augustinian Friars, which he visited with Peggy at the beginning of his stay in Vienna, to those Hapsburg hearts also wrested from the breasts in which they had formed, in which they had beaten. Hearts in exile, sealed in urns. This carving-up of the corpses of noblemen, heroes, and saints, and distributing of their limbs, bones, hair, viscera in various places seems to him a curious mixture of barbarism, obscenity, and infantile magic. What use would he have for the hearts of May, Peggy, and Lothar preserved in reliquaries?

But this splitting-up of sacred remains into separate pieces corresponds perhaps to that other phenomenon of disintegration that takes place in the living bodies of the bereft: every loved one in passing away steals a little flesh, a little blood from those who remain on earth, shivering with cold and pointlessness in the continuous drizzle of absence. Magnus's body

was diminished in this way at a very young age, when his mother, the unknown woman in Hamburg, was consumed by fire before his eyes, charring a section of his heart and transfixing his memory. And May too stole her share of his flesh, her share of his heart, mingling them with her ashes scattered in the silent blueness of the sky. Then Peggy – the great sensual abduction, and the burial of desire, of all joy, all pleasure in the black chill dampness of the earth.

Of his father he has nothing, not even an image – except maybe that first name found round the little bear's neck, which he adopted as his own? This fragile 'maybe' is the only link between them. His austere guardian Lothar, who became his protective friend, has left him with a plaster mask. A lifeless mask with closed eyelids, sealed lips, robbed of that smile of wonderful goodness that quietly illuminated the world. Lothar took with him that brightness he was capable of raising at the boundaries of thought. Magnus can no longer perceive the slightest glimmer on the horizon, whether of days past or days to come.

The decanting of time is still producing only billowing mist in the distance, and a few gaps in it that have the harsh brilliance of frost.

Such is the life Magnus leads in his Morvan solitude, forming posthumous friendships at the graveside; silent friendships with this or that tree, with an ox or a ewe encountered at the edge of a field; fleeting friendships with clouds, babbling springs, smells of earth and wind. Friendships of the here and now.

Sequence

My thought
and not a caress
And yet
I touched you
with my thought

my thought
and not a caress
like your memory
or words not spoken
or your closed eyes

and yet your memory
those words and looks
are the caress of a bygone day
on my thoughts.

Matthias Johannessen, 'To touching'

Fragment 27

Returning from one of his walks one August afternoon, Magnus notices an old woman sitting by the barn door. She is wearing a shapeless straw hat, a shift so faded it is of an indeterminate colour, and muddy overshoes. She is quietly sunning herself, with her arms folded on her chest. When she sees him approaching, she waves as if she were sitting in front of her own house and greeting a neighbour.

'Goodday to you, son!' she calls out in a reedy voice. Magnus thinks she must surely be some mentally confused old lady who has lost her way and sat down here thinking she is at her own house. Her face is very wrinkled, covered with wisps of hair, and her undoubtedly toothless mouth is all awry.

Just like the good witch in a fairy tale, Magnus says to himself. He returns her greeting, practically shouting, suspecting her of being deaf. 'Goodday, ma'am.'

The 'old lady' corrects him, laughing. 'No, son, a mere man!' And he removes his hat, uncovering a bald spotted pate. Bees that must have been dozing on his straw hat begin to flit round his head, some settling on his forehead, his face.

'But a sensible and happy man,' the little fellow adds, 'for I've made the best choice in the world, you see, the company of bees and the kind of freedom that is the sweetest madness, the madness of supreme love. That's why I'm something of a woman as well. And therefore a charmed man.' With this explanation, he nimbly gets to his feet.

He is small, very slight, with a stoop, but his body still seems as agile as that of a child. He puts his hat back on, and opens up his hands. The bees come and gather on them. He extends his bee-covered palms towards Magnus and says, 'In the hive their

queen is constantly surrounded by a very busy court of servants and workers. But for me they're all queens, especially the workers, the foragers, the fanners, the sweepers, and the guardians of the threshold. Each has its own task, which it unfailingly fulfils, from beginning to end of its brief existence. Look at them, my little queens, my bright flares! The sun's maids of honour . . .'

Magnus has not understood a great deal of what the little fellow in his muddy-coloured homespun shift has been babbling on about. His voice is thin and his rustic accent very strong. Magnus has the impression of being confronted with a clown, juggling with both tamed insects and odd utterances, or rather a scarecrow suddenly endowed with movement and the power of speech, and he wonders where the fellow comes from and what he wants. The clown flaps his hands and his insects take flight, starting to circle round him again.

'I'm Brother Jean. Who are you?'

Magnus is taken aback by this question, simple though it is, and he gives an answer that comes as a surprise to himself. 'I've forgotten.'

The clownish monk does not seem to find this reply in the least unexpected. 'That can happen. And it's a good a sign.' With this serenely delivered comment he goes toddling off, a golden flurry swarming round his hat.

No matter how much thought he gives it, he cannot recall his name. This lasting forgetfulness dismays him. He does not see any good sign in it. On the contrary, he feels stricken with anonymity, as though felled by a blow, an ailment. The sickness of loss, combining in this latest attack the stealthy attrition of wastage with the anguish of despoliation. Is this the only result of that long labour of decanting conducted in the solitude of footpaths and forests, in the silence of the barn?

Nevertheless he eventually returns to the barn. Planting himself against the back wall, he summons to his aid all those

people he has known and loved, but their names come to him in a jumble, overwhelmed by those of people who have been an affliction to him. He does not want to hear the detested names of Thea and Clemens Dunkeltal, along with all their pseudonyms stinking of lies and wickedness, nor those of Horst Witzel, Julius Schlack, Klaus Döhrlich, But these names grow shrill, they cling, sticking to his tongue.

Knautschke, Klautschke – these nicknames plague him, slosh round in his mouth, turn into seething verminous words, *Klasche Klapse Knalle Knaren Knacke Knülche Knauser Kleckse* . . .[1] Verbal smacks, verbal expectorations. He sees them as big clots of blood roiling in the pink gaping gob of a yawning hippopotamus. He feels them gurgling in his throat, thickening his saliva. He starts striking the ground with his stick to silence this viscous tumult.

Shut your trap, Knautschke! He strikes harder and harder, head down, straining his brow like an animal ready to charge, jaws clenched. So cold is he, he breaks into a sweat, chill perspiration running down his back; a stalactite reaching from the nape of his neck to the base of his spine.

A stalagmite rising from his belly to his throat. The Knautschke orifice closes, swallowing up all those reptilian words. Then out of an undercurrent of sound emerge the familiar names, like so many handshakes, greetings, smiles that pacify him. And caresses too, painful in their lost tenderness.

They come slowly circling round, all these names, in pairs or singly. Just a murmur each time, a sigh. A sob. May, Peggy . . .

A procession of utterances in colourless or grey-blue voices, ocre and violet laughter, ivory and russet whispers. Each name has its own complexion, style, timbre, and a slight tremor. A quavering sometimes. Each has its own intensity, its particular resonance. Sometimes a fleeting brilliance.

[1] Claps slaps smacks rattles crackles misers blotches

And the procession goes round and round. But his own name is absent.

He is no longer striking the ground with his stick, he is walking across the barn, pacing the emptiness. He follows after the names in the procession, begging for his own. His mouth is dry, his lips blue with cold. Darkness has long since fallen, but so profuse are the stars that a diffused pale luminescence tempers the darkness.

He lurches, leaning on his stick, still seeking his name. The starlight has faded. It is close to daybreak. The barn is now steeped in ashen gloom. The procession of beloved names dissolves in the silence. He is left on his own. He collapses with exhaustion, falls to his knees. But in falling, his mind fractures and his name suddenly resurfaces. Magnus.

Magnus laughs, on his knees in the dust. 'Magnus!' he exclaims in a breathless voice, and repeats his name as if calling out to himself. He is so happy to have recovered it he writes it in the dust with the tip of his index finger. At that moment as the sun rises the sky is filled with a milky brightness, and this dawn radiance steals between the slats of the barn, concentrating in an oblique beam that touches his finger.

A ray of white light. A lactation. And his finger does not write the letters of Magnus but those of another name, totally unknown to him.

He gazes at this name and quietly lies down beside it. He falls asleep immediately, dazed with tiredness and incomprehension.

Litany

Lothar and Hannelore, call my name.
Else and Erika, call my name.
Peggy Bell, call my name.
Mary and Terence Gleanerstones, call my name.
Terence and Scott, my brothers, call my name.
May, my lover of such vitality, call my name.
Lothar and Hannelore, call my name.
Else, call my name.
Peggy, my sister my love, call my name.
Lothar, my friend my father, call my name.
Myriam, young girl, call my name.
Peggy, my most beautiful my sweet, call my name.
Peggy, my Schneewittchen my lost one, call my name.
You, who were sacrificed, forgive me.

From the unknown, deliver me.
From this silence, deliver me.
From this oblivion, deliver me.
From disintegration, deliver me.
From my absence, deliver me.

I being nameless, in your mercy, name me!
From this perdition, in your mercy, save me!
In your mercy, listen to me!
Hear me . . .

Do you hear me?
May, do you hear me?
Lothar, are you listening to me?
Peggy, do you forgive me?

And you, my mother consumed by fire and the fire that con-
sumes me, do you hear me?
Where are you? What do you say ?
Do you hear me?

Fragment 28

When he wakes up it is already very late in the morning. Another hot August day. The atmosphere is close, laden with the smells of earth, of flowers. His head is strangely heavy, as if filled with mist, with white dew. He feels giddy. To get to his feet, he uses the ground to support his weight, but in doing so his hands erase the name dictated to him by tiredness, the name he had written in the dust at daybreak in the milky flow of light. By the time that moment resurfaces in his mind it is too late, the writing is illegible. He can only distinguish one letter: an l. So it was not a dream, he had actually written down some other unsuspected name: there is no l in Magnus. But examine the ground as he might, he cannot decipher anything more.

He pushes open the door. The direct sunlight blinds him. 'Good morning, my son! Did you sleep well?' The little old monk wearing his mobile beehive has returned, as buzzingly cheerful as the previous day. Over by the lime tree that shades the yard, he is busying himself round a table he has improvised with a wooden plank resting on some logs taken from the pile in the shed. He acts as if he is at home here, indeed like a host about to welcome a guest. For that is what he is preparing: lunch.

On the board are a jug of water, a bottle of wine, three glasses, fruit, saucisson, cheese, a pot of honey and some bread, and even a posy of golden clover and agrimony.

'You must be hungry,' he says. 'If it's all right with you, we'll have lunch straightaway. It's already midday. The meal may be frugal but it's none the less festive. Because today is the fifteenth, the day of Mary's Assumption. In honour of which

I've brought a bottle of wine, a very good wine, a Pouilly Fumé. And you know what? It's also my birthday. I was born on the night of the fifteenth of August, but so long ago I can't remember the exact year any more. It was towards the end of the last century. It was a tradition, or rather a blessing, in my family: all the children were born on the fifteenth of August. And I had a lot of siblings – nine boys, would you believe? Who all came into the world under the protection of the Virgin. So this birthday isn't just mine, it's also that of my eight brothers. All of them have died now, gone to pay their respects to the Immaculate Mother of God. Soon it will be my turn. Ah, what a beautiful day!'

Dazed by the chatter of this tiresome votary of the Virgin, Magnus is not sure whether the beautiful day he has just referred to is this one, or that of his forthcoming death. But he does not care either way, and the presence of the talkative monk irritates him. Yet he dare not drive him away. He politely beats a retreat, pleading tiredness in order to seek refuge inside the house where, he hopes, the intruder will not, after all, have the gall to follow him. But the fellow is not to be put off, and resumes his chatter with exasperating cheek.

'Sorry, my son, but I haven't got time to wait any longer. So you think I came on a whim, do you? I've been watching you for a long time, since the day you moved into this isolated house, nearly three years ago. And not a day's gone by that I haven't seen you, passing here or there . . . But you've never noticed my presence, although I live mostly nearby. The number of times I've slept in the stable beside the barn where you spend hours shut up inside! There is still straw in the mangers, and I like to come and lie down in it, it's warm and smells goods. The animals have left behind a little of their warmth, their gentleness, their wisdom . . . Anyway, you prefer the barn. Why not? But enough's enough. Haven't you had your fill of emptiness in that barn of yours?'

'Mind your own business,' replies Magnus, annoyed to discover that he has been spied on by this old busybody. 'Leave me in peace!'

Brother Jean does not give up. He returns to the fray. 'Peace! It's not by isolating yourself that you'll find peace. For that's what you are: isolated, not a recluse. Lonely, not a loner. I know what I'm talking about, I've been living as a hermit for some thirty years, close to my monastery. I'd never have been able to keep going if I had a heart as bleak as yours. The heart of a sequestered man.'

'Sequestered?' echoes Magnus, who does not know this word.

'Confined, detained, imprisoned, walled up . . .' explains the monk, and immediately continues with what he was saying. 'I keep bees. My hives are not far from here. I take the honey to the monastery, and receive food and clothing in exchange. I need very litte. Less and less. Soon I shan't be needing anything at all. That time is near, which is why I've come to you.' Then abruptly changing the subject, he asks, 'So what about your name, did you remember it?'

'Magnus.'

'Ah? Are you sure?' says Brother Jean with a dubious look, as if he already knew the answer and the one he had been given was incorrect.

This response once again disconcerts Magnus, who is well aware he has a borrowed name shared with a teddy bear, and that this very morning he obliterated another name, which might have been his.

'Why do you doubt my name?' he asks.

Evading the question, his interlocuter says, 'Names! Bah! People sometimes change them in the course of their life, as if the one they were given at birth wasn't the right one. I had to give up mine when I entered the monastery, and I wasn't given any choice. My name used to be Blaise. It was taken

away from me. You'll be called Brother Jean, they said. So Jean it was. Like the Baptist who fed on locusts and honey, or the Evangelist. Now there's someone who was enlightened by a visit from the Angel of mystery! The Angel of the Word . . . Yes, the Angel of the Word, who made him eat up the little book of fire. In my opinion, that book was a beehive comb dripping with honey. I'm just a very insignificant Jean, and the Angel of the Word split my lip by sealing my mouth with his secret . . . But for some time now I have had the feeling this secret is stirring . . . yes, it's stirring in my mouth, on my split lip . . . it's like a taste of wind . . .'

'What are you talking about? What secret?'

'As if I knew! Who is familiar with the gift of God?'

'Certainly not me!' exclaims Magnus. 'And it's no concern of mine. I'm not a believer.'

'So much the better,' retorts Brother Jean, who takes everything in his stride. 'That makes you freer. Free to be surprised by what I, on my own, have not yet been able to experience. That's why I need you.'

The gift of God! A charming fantasy. Magnus can make no sense of Brother Jean's vatic utterances, but his irritation has subsided. He no longer has any desire to argue with this innocent whose persistence is matched by his eccentricity. All he wants is to rest and have something to eat, hunger suddenly overtaking his tiredness. They sit down side by side in the shade of the lime tree. A small cloud of bees swirls round them. They empty the bottle of Pouilly, sharing the contents of the third glass that Brother Jean had filled with the Angel of the Word in mind, or any other visitor who might turn up. More talkative and more crazy than ever, he draws a parallel between the ingenious system devised by Vauban for beseiging a fortified town, using zigzag trenches, and the delicate labyrinth of paths leading the soul towards God. Then he elaborates another parallel between the ripening of fruit by

the effect of heat and the bringing to maturity of his death by the effect of time, a process he feels is about to reach completion.

Magnus listens with only half an ear. He is feeling tired again. His companion starts singing, his voice still tuneful. He intones the litany of the Virgin in Latin. Then he rises and calmly announces, 'I shan't be coming back again. Next time, you'll come to me. I can rely on you, can't I?'

Magnus reminds him that he does not know where he lives, if indeed he lives anywhere.

'Not to worry, I'll send my bees to fetch you. All you have to do is follow them.'

And as on the previous day, he trips off amid a buzzing of insects.

Magnus watches Brother Jean go, the figure of an elderly child in perpetual flight. A wood sprite who frolics with bees, who wields words illuminated like the pages of an old missal. Magnus feels as if he has been unwittingly introduced into a fairy tale. An antiquated tale inadvertently inserted into the rambling story of his life. It was charming, but he thinks he would have preferred to be invited into a completely different narrative: he has outgrown fairy tales. The secret of the Angel of the Word! He would be content to see the more modest secret of his early childhood finally explained, and even more so the secret of the vast nowhere into which the dead disappeared. The gift of God! But it is the gift of life that Magnus wants – and for the gift of life to be returned to those who have been robbed of it.

Insert

Once upon a time . . . This is how all stories that have never happened begin. Myths, fables, legends.

The story told has dissolved into a distant past, like vegetable matter in marshland, or bodies in humus, giving rise to will-o'-the-wisps that flit through the darkness, skimming the ground. Likewise do the elements of myths and fables act in the obscurity of our thoughts.

Once . . . an imprecise word referring to a past to which no date can be put. Or the one particular occasion on which an event took place.

Once upon a time . . . So which is it? A once and for all occasion that did indeed happen or a once of eternal vagueness, for ever unresolved? Its temporal status remains ambiguous.

Once upon a time . . . A ritual formula that leads into a story, like a little hidden door opening onto an inner courtyard or a secret corridor. But in what sense have they never happened, these stories unrecognized by History, which admits into its corpus only established proven events whose relation to reality is exclusively diurnal. What do we know of what happens in the night time of reality? The imaginary is reality's nocturnal lover.

The corpus of History is a body – whose flesh is language, words spoken and written – and like all bodies it is opaque, and therefore casts a shadow. *Once upon a time* is this shadow it produces, a counterpart of more fluid, shifting words and utterances.

Once upon a time: corpus of a deeper, more intense memory than that of History; seedbed of reality, which by morning has forgotten this pre-seeding, retaining only the visible palpable traces of it.

Presently, there are sometimes stray characters who seem for ever to roam reality's darkness, and who migrate from one story to another, constantly in search of some word that would finally give them full access to life, even at the cost of their own death.

The time may come when characters encounter each other at the intersection of stories that have lost direction, stories yearning for new stories, ever and always.

Fragment O

The summer is nearly over. Brother Jean has not reappeared. He must have been having impish fun among his hives. Magnus hardly gives him any thought, but since that lunch they had together he has no longer felt the need to shut himself up in the barn. More importantly, he is thinking of leaving this place, this solitude. He is ready to move on. The monk was right, he has had his fill of emptiness and seclusion. The heavy silence deposited inside him is beginning to clear, to stir. And this sun-ripened silence, as Brother Jean might say, is impelling him to be on his way again.

He is preparing for his departure, this time in tranquil indifference, no longer in the haste of grief and shame.

They turn up one morning in a sonorous cloud. They fly swiftly through the air, undulating, at the height of a man. Magnus sees this golden brown ball rushing towards him. He takes fright, thinking he is being attacked by a swarm. But the cloud halts one metre from his face. The buzzing is agitated. Magnus recalls what Brother Jean said, that he would send his messengers when the time came. Yet he hesitates to take seriously the hermit's whimsical promise.

The little cloud hangs there, wavering, buzzing louder and louder, then retreats slightly. Magnus takes a step forward. The bees move away an equal distance. He takes another step forward. The same thing happens. Then he starts walking, resolutely following their lead.

He is led along paths he has never taken before, shortcuts across fields and through groves. His guides move fast, he can hardly keep up. He crosses the river at a point where it is very deeply embanked, via a wooden footbridge that pitches

at every step. He enters a forest, comes to a clearing. He recognizes it as the one where he once rested, to which he never found the way back again.

The bees disperse, returning to their hives. Brother Jean is sitting in the middle of the clearing, with his back resting against the mossy niche. He is wearing a voluminous black cape with a gaping hood on the back of his neck. 'Goodday to you, son!' he greets Magnus as on every previous occasion. 'Come and sit next to me.'

Magnus sits down beside him. He says nothing, asks no questions. He waits for his host to start the conversation. But the monk, usually so exuberant, remains silent, and does so for a long time. The forest around them emits a murmur of multiple sounds with the underlying humming from the hives in the background: the rustling of foliage, the swishing of grass, the chirping of insects, the splashing of a stream, the cracklings of dry twigs; little piercing cries or piping calls from the birds; the whistling and sighing of the wind; and now and again the barking of dogs and echoes of human voices in the distance.

Brother Jean looks up at the foliage of a beech tree, and pointing at a few leaves that have just detached themselves and are beginning to fall to the ground, he murmurs to Magnus, 'Listen!' The oval-shaped leaves, already brown, come slowly fluttering down. Three of them, caught in a rising air current, hover in the tree-top, like coppery commas dancing in the well of light shafting through the mass of branches. Vagabond commas punctuating in total freedom a luminously unadorned text. But all of a sudden they come tumbling down, the air current having moved on to blow elsewhere.

'Did you hear that?' asks Brother Jean.

Magnus has watched this vegetal farandole closely. He can describe it visually but not aurally. The little fellow settles back into silence. Magnus realizes that as long as he is unable to

distinguish the soft sigh of a falling leaf against the background of the various sounds of the forest and the *basso continuo* of the hives, his companion will say nothing. The hours slip by, the air gradually cools. The scene of red leaves falling recurs a countless number of times. So many erratic silent commas.

Magnus gives a slight start, turns his head to the left. His gaze catches the moment a translucent yellow leaf, as fine as an insect's wing, reaches the ground a little way off from him. His hearing perceived it before his eyes, better than his eyes. 'I'm listening,' he says to Brother Jean. But instead of finally breaking the silence Brother Jean pulls the hood of his cowled robe over his head and huddles up, with his hands flat on his knees, his forehead bowed. Thus wrapped in his black chrysalis, he dozes off. His head nods, eventually falling on Magnus's shoulder. His breathing falters, becomes deeper and slower.

That is all – no blazing light, no agitation in that drowsy body, no throaty rattle or muttering from his lips. Just this breathing rising slowly, amply, from the depths of a body concentrated not on itself but on self-oblivion, on an excavation, a hollowing-out of the self. And this breathing grows lighter, easier. It is as soft and penetrating as the sound of an oboe. A sigh of light escaping from the darkness. A vocal smile quietly ringing in the air. An exhalation of silence.

That is all, but so totally have these two men surrendered to listening to this breathing and so united are they in their surrender, Magnus is overwhelmed by it. This tenuous song wells up as much from his own body as his companion's, it caresses his flesh under his skin, flows in his blood. This caress felt from inside his body stirs him, amazes him, and engulfs him in himself more powerfully than any caress exchanged in love-making. This very fleeting embrace derives from way beyond anything he has previous experienced. It is radically

new, a mental and carnal abduction of thrilling delicacy. It is life itself embracing him from within, and with one impulse he encompasses it with all his senses.

Brother Jean rouses from his somnolence, lifts his head and snorts. His breathing has returned to normal. And Magnus does likewise. They are attuned. They get to their feet. Brother Jean pushes back his cowl, uncovering his head. His face bears the trace of the intentness of mind he has just exacted of himself – his face that of a very aged infant wakened by a dream mounting inside him whose amplitude he cannot contain, his brow creased by this upsurge of pure energy, his eyes clouded with a vision already receding.

'Go home,' he says. 'Come back when you're needed. It won't be long, tomorrow, or in a few days' time. You'll know when to return and what you must do. You can find your way now.'

He walks with Magnus to the edge of the forest. 'When it's all over,' he says, 'go and tell my brothers at the abbey. Take them my robe, it's theirs by right. That's where I was given the habit. It doesn't belong to me.' He gazes at the landscape for a moment. 'I've enjoyed my life,' he adds, 'and loved this countryside where I've always lived.' Then he turns to his companion, gives him a quick hug, and flits away towards the clearing.

Palimpsest

There is a spirit that man acquires over the course of time. But there is another spirit that enters man abundantly and rapidly, more rapidly than the blinking of an eye, for being itself beyond time this spirit has no need of time.

<div align="right">Rabbi Nahman of Bratslav</div>

. . . he will see that there is no limit to his intellect, and that he must search deeply . . . in the place where the mouth is incapable of speaking and the ear incapable of hearing. Then, like he who sleeps and whose eyes are closed, he will see visions of God, as it is written: 'I was asleep but my heart waked, it is the voice of my beloved that knocketh'. And when he opens his eyes, and still more when another speaks to him, he will choose death rather than life, for it will be to him as if he were dead, for he will have forgotten what he saw. Then he will study his spirit as one studies a book in which great marvels are written.

<div align="right">Rabbi shem Tovibn Gaon</div>

God never does the same thing twice. And when a soul returns, another spirit becomes its companion.

<div align="right">Rabbi Nahman of Bratlav</div>

Fragment 29

Magnus returns two days later. He has been given no particular sign, he simply has the clear conviction the moment has come. When he enters the clearing he notices a long black shadow projecting from the niche, which bears no relation to the size of the niche or to the sunlight. It is a narrow trench, quite deep, with a spade set beside it, and the neatly folded robe.

An intense buzzing rises from this trench; it is seething with thousands of bees. And now suddenly they all take flight, shooting up like erupting lava. The quivering, twisting column climbs into the treetops, then fragments and scatters in an amazing shower of gleaming yellow. Every bee returns to its usual task.

At the bottom of the trench lies Brother Jean, with his rosary wrapped round his hands, which are crossed over his breast. His body is completely covered with bee-glue, and glimmering with a reddish lustre. A few bees, exhausted by their work of embalmment, are lying on the body, sprinkling it with gleams of pale gold.

Magnus seizes the spade and fills the grave. The sweet smell of the balm mingles with the dank bitter smell of the humus.

He takes Brother Jean's robe back to the abbey. But the habit is so worn, patched up all over, it is good for nothing but rags.

He attends the old monk's memorial service. The abbot gives a brief summary of the career of Blaise Mauperthuis, who entered the monastery as a convert at a very young age, early in the century, becoming a monk a few years later, and eventually a hermit. But a hermit resembling those bees he so loved (to the extent of choosing to lie among them in the

depths of the forest); one who was always gravitating towards the monastery, bringing his pots of honey and news of the trees, birds, and wild beasts to which he became closer than to his religious brothers. Brother Jean, an outlandish monk, who was said to have displayed in equal measure eccentricity and sensibility, ingenuousness and a refusal to forgo his independence. But the abbot bows before the mystery of every vocation, and he concludes by relating with some humour a few anecdotes about this bee-loving friar who as he grew older had acquired the habit of addressing all men, even his superior, with a joyful "Goodday to you, son!' and all women with a 'Goodday to you, daughter!' He remembers the day when Brother Jean turned up at the abbey in a great state of agitation to report that someone had stolen the statue of the Virgin from the clearing where he had set up his beehives. At first this theft had upset him, then having thought about it he reached the conclusion that it was all right for the robbed niche to be empty, and he decided the absence of a statue would now celebrate Our Lady of the Empty Space. Delighted with this idea, he had asked the abbot if he would come and bless the non-existent statue. Everyone in the congregation bursts out laughing at the account of this incident that took place a few months ago, and Magnus joins in the hilarity that long resonates in the church.

He closes the door of the house. That of the barn remains ajar; the lock has been broken for ages and he has never seen any point in fixing it. The wind blowing in through the open door has completely effaced the name he wrote in the dust. Not that this matters any more. The name is written on the cortex of his heart. A name as light as a bird nesting on his shoulder. A name burning in the small of his back, urging him to be off.

He is not running away any more, he goes to meet his name, which always precedes him.

His bags will not be heavy, he is taking practically nothing with him.

He has buried Lothar's death mask at the foot of the lime tree under which Brother Jean set up the table for lunch on the fifteenth of August. Lothar, and also May and Peggy, could have joined them at their table that day to share the glass filled in honour of the Angel of the Word. Such a glass is ever replenished, ever to be shared.

As for the teddy bear, left too long on a shelf in the wardrobe in his bedroom, there is nothing much left of him: the moths have been at the wool of his face, mice have nibbled his paws and ears, and filched the stuffing from his stomach. Magnus drops the tattered bear into the waters of the Trinquelin, a little stream that runs past the abbey. Magnus the bear drifts away, his buttercup eyes glinting with cold water and sunshine.

The only book he takes is the one that has opened inside him with the breathy sound of an oboe, playing in a constant undertone in his mind, his breast, his mouth. The pages of the book quiver in his hands, fall one by one under his feet.

To be gone, sings the book of marvels, the book of the unsuspected, to be gone . . .

To be gone.

Fragment ?

Here begins the story of a man who . . .

But this story eludes all telling: it is a precipitate of life, suspended in reality, so dense that all words fragment on contact with it. And even if words resistant enough might be found, the telling of it, at a time removed, would be thought the wildest fantasy.

> '*To be gone! To be gone! Cry of the living!* . . .
> *To be gone! To be gone! Cry of the Prodigal!*'

Saint-John Perse, *Winds*

Translator's Afterword

When translation rights in Sylvie Germain's first novel *Livre des Nuits* (*The Book of Nights*) were offered to British publishers in 1987, I was asked to write a report on it. Reading it was a thrilling experience: this wonderful book told an enthralling story with remarkable lyrical intensity and great imagination, and there was nothing like it in English, which made it an ideal candidate for translation.

Despite its obvious merits, to my amazement it was not immediately taken up by any British publisher. Certain that it must eventually be published in English, and hoping that I might at least offer myself as the translator, every now and again I would check with Gallimard whether the rights had been sold.

In early 1990 I learned they had been – to the American publisher David R. Godine, based in Boston; the translation was supposedly far advanced and publication imminent. When I contacted Godine, happily for me this turned out to be untrue. I submitted a sample and was contracted to do the translation, to which Godine allowed me to retain the British rights. In the end Dedalus bought these and when I completed the translation in 1992 Dedalus were able to publish first, Godine bringing out their edition in 1993. It is greatly to the credit of these two independent publishers that they have made the work of a writer of the stature of Sylvie Germain available in English.

Publication of her first novel has been followed up over the intervening years with a considerable literary output: eight further novels, all of which have been published by Dedalus, as well as numerous collections of essays – on literature, art,

aesthetics, ethics – and spiritual meditations, a literary portrait of Krackow, a reflection on the life of Etty Hillesum, and even a children's book. Sylvie Germain's writing is now the subject of increasing academic interest, not only in France and the UK but in university departments worldwide, from Pretoria to Haifa and Texas to Genoa, with doctoral theses, critical studies, conference papers, and entire conferences – in 2005 the Biennial Conference of the Association Européene François Mauriac held at Exeter University, and in 2007 the Colloque Sylvie Germain held at Cerisy-la-Salle in Normandy – devoted to the myriad aspects of her work.

Tackling the theme of evil – in the barely conceivable horror of the Holocaust, in the inhumanity of torture and its dehumanizing effect on the perpetrator, in the mindless and gratuitous act of violence, and in the complicity of the bystander who does not intervene – spanning over a hundred years of turbulent, war-torn, French and European history, and peopled with dozens of characters whose genealogy is traced through several generations, *The Book of Nights* and its companion volume *Night of Amber* are hugely ambitious in scope. Thereafter, the author's focus closes in, becomes more concentrated: *Days of Anger* (winner of the Prix Femina 1989) and *The Medusa Child* explore the drama of perverted desire within what becomes, from one novel to the next, an increasingly nuclear family.

Published between the latter two books is *The Weeping Woman of Prague*, more of a novella or extended prose poem, in which a narrator observes and reflects on not so much a character as a ghostly presence haunting what might be regarded as the cultural heart of Europe, the *genius loci*, an emanation of the streets of the city which had by this time become the author's home (she moved there in 1986) and place of work (teaching philosophy at the French school), and which was to provide the setting for two subsequent novels.

Against the backdrop of the collapse of communism and the cynicism and moral bankruptcy of the new order, the protagonists of *Infinite Possibilities* (*Immensités*, 1993) and *Invitation to a Journey* (*Éclats de Sel*, 1996), both of them intellectuals, lead bleak and cheerless lives without direction or sense of purpose. The world seems to conspire against them, and they do not at the outset have Job's faith to sustain them in their trials and tribulations. There is a somewhat more metaphysical, cerebral dimension to the texture of this writing, in which the author's fertile imagination, surprising inventiveness, and talent for story-telling nevertheless continue to find expression.

Her next novel, *The Book of Tobias* (*Tobie des Marais*, 1998), which moves from a Jewish shtetl in Polish Galicia to the Poitevin Marais, on the west coast of France (Sylvie Germain herself returned to France around this time), is a reworking of the biblical story of Tobias and the angel, taking the essential structure of it, mythopoeically weaving into it more recent, twentieth-century history, and grafting on to it a narrative of sometimes gothic quality reminiscent of her first novel. She explores the by now familiar themes of perverted desire, the self-destructive power of hatred, the need for forgiveness and compassion.

For Sylvie Germain, these remain inexhaustible themes. Her novels inevitably come to an end, but they never come to a conclusion.

'The last word does not exist. There is no last word, last cry.' (*The Book of Nights*).

The author never takes up a fixed position, never settles into complacency, but embraces the challenge of the open question, the constant search, of remaining ever the nomad of inner geographies, just like Laudes-Marie Neigedaoût of *The Song of False Lovers* (*Chanson des Mal-Aimants*, 2002), which recounts the odyssey of the vagabond foundling whose whole life, 'is but an approach, so zigzagging that sometimes I have

gone backwards' towards the blessing of a fleeting moment of enlightenment.

While Sylvie Germain has acknowledged that *The Book of Nights* perhaps contains in essence the seed of all her obsessions as a novelist, she has also described the writing of every novel as a totally new adventure, an experience that might be compared with embarking on a new love affair, and that if there were not that sense of adventure there would be no point in writing.

Each book begins with a mental image that by its very persistence begins to intrigue the author, and then goes through a long process of development, of maturation, with all kinds of feelings, emotions, thoughts, memories, ideas, personal experiences and external stimuli – things heard and seen and read, historical events, anecdotal stories – gradually crystallizing around it, defining it and making sense of it.

The image of Jacob wrestling with the angel was the germ from which *The Book of Nights* and *Nuit-d'Ambre (Night of Amber)* were brought into being, the story elaborated through this process unable to be contained within the confines of a single volume as the author strove to explain the origins of her character, and in so doing creating a sprawling, magic realist, dynastic saga, resonant with voices from the past.

With *Magnus*, the inspirational image is that of 'a man, seen from behind, in a kind of impasse, in the dark'. The work of the novelist, dwelling on this image and seeking to give it substance, is reflected in the enterprise the main character himself must undertake, to create a history and an identity for himself, circumstances having contrived to rob him of both, while his tentative and patchy progress in this endeavour finds expression in the novel's discontinuity and mosaic structure, composed of narrative fragments, quotations from other writers and eminent personalities – novelist, poet, dramatist, anthropologist, theologian or civil rights

activist – snippets of social and historical commentary, potted biography.

'Who's there?'

In the first of her essays published under the title of *Cépha-lophores*, Sylvie Germain takes as her theme the opening words of Shakespeare's *Hamlet*. 'Who's there?' is the question that might be asked by any reader opening the pages of a book, but is also the challenge the author picks up in bringing out of the shadows the characters that people a text, writing being a way of satisfying a compelling curiosity, the desire to know more, to give texture and voice and movement to vague solicitous presences that intrude on the writer's consciousness, claiming attention.

And just as *Magnus*, as a child scared of the dark, comforts himself by whispering fragments of stories into his teddy bear's ear, 'preferably the left ear, the one that has been injured and therefore needs special care', so this novelist's attention is caught by the plight of history's victims, of those who suffer man's inhumanity to man, and those who unwittingly per-haps do violence to themselves in seeking revenge for wrongs they have suffered – those who because of their injuries need special care.

In this novel, as in her previous works, Sylvie Germain celebrates as a palliative the power of story-telling, the forging of a text out of potentially inexhaustible material, access to which requires of the writer the excavational skills of an archaeologist and a kind of mystical self-effacement and recep-tiveness to the paradox of bringing expression out of silence, light out of darkness, and allowing dream to enter reality.

'To write is to descend into the prompter's box and learn to listen to the breathing of language in its silences, between words, around words, sometimes at the heart of words.'

(*Magnus*)

And of all words names are perhaps the most significant: it is of course no accident that Magnus's adoptive family name is Dunkeltal, evoking the shadow of the valley of death, and the name Magnus itself, the author herself has pointed out, is in its sonority suggestive of elusiveness, of something that cannot be pinned down.

> 'There is not one word that does not carry in its recesses eddies of light and volleys of echoes, and which does not quiver at the urgent plying of other words.'
>
> (*The Book of Nights*)

While Sylvie Germain's writing is steeped in the Catholic liturgy and biblical texts it is also informed by her reading of an extraordinary wide range of other writers from many different literatures – including Czech, Icelandic and Latin American, as well as English, French and German – whose work she often quotes directly in her own books. Her exploration of the themes of forgiveness, and of redemption and salvation through love – the overriding concern of all her books – reflects a profoundly spiritual sensibility, but there is nothing formal or static or immutable about her apprehension of the numinous. It rejoices in the fugitive, the precarious, the protean, in mystery and mutability. It is generous and accepting and inclusive.

Who is Magnus? Like all of us, an individual, seeking an identity for himself, a reconciliation with his existence, and hoping to find happiness.

Recommended Reading

If you enjoyed reading *Magnus,* there are other books on our list, which should appeal to you. Sylvie Germain's writing is unique but what her very different novels all have in common is the ability to touch the heart and engage the mind. Her novels are metaphysical quests for the meaning of life from someone who is still searching with an open mind. We recommend her other nine novels but in particular:

The Book of Nights
Night of Amber
Days of Anger
Infinite Possibilities
The Book of Tobias

Magnus won The Goncourt Lycéen Prize in France. A jury made up of 15–18 year-old High School students selected *Magnus* as the best novel published in 2005 from the 12 novels shortlisted for the main Goncourt Prize. Other books on our list, which should appeal to young people who like literary fiction, are:

The Medusa Child – Sylvie Germain
Alfanhui – Raphael Ferlosio
Theodore – Christopher Harris
The Mysteries of Algiers – Robert Irwin
The Revenants – Geoffrey Farrington

If you enjoyed the emotional intensity and the gritty realism of raw emotions that characterise parts of *Magnus* you should enjoy the novels of Yuri Buida and Paul Genney:

The Zero Train – Yuri Buida
The Prussian Bride – Yuri Buida
Pleading Guilty – Paul Genney

If you like books with stories within stories and literary game playing, we recommend the following books:

Music, in a Foreign Language – Andrew Crumey
Pfitz – Andrew Crumey
D'Alembert's Principle – Andrew Crumey
The Arabian Nightmare – Robert Irwin
The Limits of Vision – Robert Irwin
 Exquisite Corpse – Robert Irwin
Satan Wants Me – Robert Irwin
A Box of Dreams – David Madsen
The Double Life of Daniel Glick – Maurice Caldera
The Angel of the West Window – Gustav Meyrink
Stephanie – Herbert Rosendorfer

These can be bought from your local bookshop or online from amazon.co.uk or direct from Dedalus, either online or by post.. Please write to **Cash Sales, Dedalus Limited, 24–26, St Judith's Lane, Sawtry, Cambs, PE28 5XE**. For further details of the Dedalus list please go to our website www.dedalusbooks.com or write to us for a catalogue

The Book of Nights – Sylvie Germain

"The Book of Nights is a masterpiece. Germain is endowed with extraordinary narrative and descriptive abilities . . . She excels in portraits of emotional intensity and the gritty realism of raw emotions gives the novel its unique power."

Ziauddin Sardar in *The Independent*

"The novel tells the story of the Peniel family in the desolate wetlands of Flanders, across which the German invaders pour three times – 1870, 1914 and 1940 – in less than a century. It is hard to avoid thinking of *A Hundred Years of Solitude* but the comparison does no disservice to Germain's novel, so powerful is it. A brilliant book, excellently translated."

Mike Petty in *The Literary Review*

"This is a lyrical attempt to blend magic realism with *la France profonde*, the desolate peasant regions that remain mired in myth and folklore. Nothing is too grotesque for Germain's eldritch imagination: batrachian women, loving werewolves, necklaces of tears and corpses that metamorphose into dolls all combine to produce a visionary fusion of the pagan and the mystical."

Elizabeth Young's Books of the Year Selection in *The New Statesman*

". . . a lithe, magical-realist account of how the primordial woods of northern Europe were overwhelmed by the twentieth century both tremulous and shocking."

James Saynor in *The Observer*

£8.99 ISBN 978 1 873982 00 6 278p B. Format

Night of Amber – **Sylvie Germain**

Night of Amber ranges from the terror and atrocity of the Algerian War, the Paris of the 1960s and an unforgettable evocation of *la France profonde* with a host of memorable characters. It is a powerful and emotional novel, which takes *The Book of Nights* to its dramatic conclusion.

"There is little that can be said that would do justice to the controlled brilliance of Sylvie Germain's writings – *Night of Amber* is a fantastic book, a wildly inventive novel about childhood, death, war and much else. It creates a rich fantasy world, yet it is also very moving, and deals with the emotions of grief and love with an understanding and insight which few writers can match."
> Edward Platt in *The Sunday Times*

"Germain's sequel to her prize-winning first novel, *The Book of Nights*, follows her anti-hero Charles-Victor Peniel on his hate-filled journey through life. It sings with a strange poetry, pitting politics (the Algerian war and May '68) against the vagaries of individual minds."
> Ian Critchley in *The Daily Telegraph*

"Sylvie Germain is arguably the greatest writer of her generation."
> *Meridian Book Programme, BBC World Service*

£8.99 978 1 873892 95 2 339p B.Format

Days of Anger – **Sylvie Germain**

Winner of the Prix Femina.

"A murdered woman, lying buried in the forests of the Morvan, is the still beating heart of *Days of Anger*. A rich, eventful saga of blood, angels, obsession and revenge, this marvellous novel is a compulsive, magical read, passionate and spell binding."
 James Friel in *Time Out*

"It reads like Thomas Hardy rewritten by some hectic surreal-ist and it plants in its rural glades a medieval vitality."
 Robert Winder in *The Independent*

"Germain's creations are strong such as Hubert Cordebugler, the despised village knicker-thief who recycles lingerie in his secret love-chamber, and Fat Ginnie, a voluptuous, towering sherry trifle of a woman who gives birth to a strapping son every Feast of Assumption. An icon for women of substance everywhere."
 Geraldine Brennan in *The Observer*

"Fans of Angela Carter will relish the latest Gothic romance from her French near equivalent, Sylvie Germain."
 Boyd Tonkin in *The New Statesman*

£8.99 **ISBN 978 1 873982 65 5** **238p** **B. Format**

The Medusa Child – Sylvie Germain

"*The Medusa Child* is her most accessible novel, and my favourite. A coherent pattern of metaphor depicts an enchanted country childhood. Lucie explores the marshes around her home and studies the stars. But when she is given a room of her own, an ogre starts to pay her nocturnal visits. Helpless and alone, Lucie decides to fight back by turning herself into a monster. This is a superb and compassionate study of damage and resistance."

Michele Roberts in *Mslexia*

"Sylvi anslated from tl violent story a ; a myth from la

"Germ h with religio cadence so love

"The ascetic sex scenes between the eight year old and the 'blond ogre', and omnipresent sense of sin and salvation, show what a good writer Germain can be."

Carole Morin in *The New Statesman*

£8.99 **ISBN 978 1 873982 31 0** 246p **B. Format**